®
teach
yourself

**digital photography
for the over 50s**

**digital photography
for the over 50s**

peter cope

for over 60 years, more than 50
million people have learnt over 750
subjects the **teach yourself** way,
with impressive results.

be where you want to be
with **teach yourself**

For UK order enquiries: please contact Bookpoint Ltd, 130 Milton Park, Abingdon, Oxon OX14 4SB. Telephone: +44 (0)1235 827720. Fax: +44 (0)1235 400454. Lines are open 09.00–17.00, Monday to Saturday, with a 24-hour message answering service. Details about our titles and how to order are available at www.teachyourself.co.uk.

For USA order enquiries: please contact McGraw-Hill Customer Services, PO Box 545, Blacklick, OH 43004-0545, USA. Telephone: 1-800-722-4726. Fax: 1-614-755-5645.

For Canada order enquiries: please contact McGraw-Hill Ryerson Ltd, 300 Water St, Whitby, Ontario L1N 9B6, Canada. Telephone: 905 430 5000. Fax: 905 430 5020.

Long renowned as the authoritative source for self-guided learning – with more than 50 million copies sold worldwide – the **teach yourself** series includes over 500 titles in the fields of languages, crafts, hobbies, business, computing and education.

British Library Cataloguing in Publication Data: a catalogue record for this title is available from The British Library.

Library of Congress Catalog Card Number: on file.

First published in UK 2008 by Hodder Education, 338 Euston Road, London NW1 3BH.

First published in US 2008 by The McGraw-Hill Companies, Inc.

The **teach yourself** name is a registered trademark of Hodder Headline.

Computer hardware and software brand names mentioned in this book are protected by their respective trademarks and are acknowledged.

Copyright © 2008 Peter Cope

Typeset by MacDesign, Southampton

Printed in Great Britain for Hodder Education, a division of Hodder Headline, an Hachette Livre UK Company, 338 Euston Road, London NW1 3BH, by Cox & Wyman Ltd, Reading, Berkshire.

The publisher has used its best endeavours to ensure that the URLs for external websites referred to in this book are correct and active at the time of going to press. However, the publisher and the author have no responsibility for the websites and can make no guarantee that a site will remain live or that the content will remain relevant, decent or appropriate.

Hodder Headline's policy is to use papers that are natural, renewable and recyclable products and made from wood grown in sustainable forests. The logging and manufacturing processes are expected to conform to the environmental regulations of the country of origin.

Impression number 10 9 8 7 6 5 4 3 2 1

Year 2011 2010 2009 2008 2007

v

contents

This book has been specially designed to introduce the more mature reader to digital photography. We have made few presumptions other than that readers will have some vague familiarity with photography of some sort. You might, for example have a conventional camera – by which we mean one that takes film – that you carry everywhere with you. Now you've decided it's time to go digital. Or, you've not used a camera for some time and have thought that now it's time to take the plunge again. Perhaps you've just gained some grand-children or are planning some exotic travels and want to ensure a record of events.

The good news is that digital photography is, in many senses, easier than conventional. You get to see results straight away and you can shoot all day without worrying about getting to the end of the roll of film. That makes it more economic too!

For many, the best thing about digital photography is that you can use your computer – the same one that you use for e-mails and writing your letters – to print and even to enhance your photos. No need to make those trips to the local photo lab to get your prints. You can also use your photos as the basis of greetings cards, calendars and gifts. You can even produce professional-looking photo albums and slide shows that you can enjoy on your TV.

In this book we take things in a logical order, developing your skills as we go. We'll begin by looking at how to choose a camera. Digital technology has provided many benefits, one of which is choice. No matter what your budget or your aspirations, there are cameras ideally suited to you. Got a camera already? Then you'll discover some of the things you can do with it.

We'll also look at essential accessories. Digital photography can become compulsive and you'll be drawn into adding accessories to make you photography even better. We'll take a look at what's good, what's essential and what should be left on the dealer's shelves.

Taking a digital photo is easy. Taking a good digital photo needs skill – just a little. We'll discover some of the rules, tips and hints that can lift your photography and enable you to take shots that are powerful and memorable.

Progressing, we will then examine what you can do when you combine your camera with your computer. How easy is it to manipulate and enhance your photos? How can you produce great prints to enhance your wall or give away to friends and family?

We also look at some alternatives to using your computer. If you don't have a computer – or don't want to use a computer – we'll examine your options. We'll also take a look at what you can do with all those old photographs, negatives and slides that you may have and how digital technology can breathe new life into them too.

When it comes to computers, things can get a bit confusing. Not only do you need to get to grips with the computer itself (and our companion title *Teach Yourself Computing for the Over 50s* can come to your rescue here) but also the software applications. It's these that help your computer deliver all that is asked from it. Trouble is that this software is continually being revised, updated and replaced. That's generally good – new versions usually have better specifications, are more comprehensive and less prone to bugs. It does mean, however, that the software we use in this book may be different – even slightly – from that which you might use. We have opted for the most popular applications where relevant in this book but we've also tended to concentrate more on the principles than the detail. So, whatever software you choose (or prefer) to use you shouldn't have any problem.

Best of all, digital photography is fun, whether you want to shoot just a few great photos of your holiday or family or take on something more serious. Let's start exploring.

01

choosing a digital camera

In this chapter you will learn:

- why your needs, ambitions and style can help select a camera
- some terminology and technology
- about different camera types
- how to shortlist cameras
- how and where to buy

What's the best single piece of advice you can be given when you set out to find a camera? Arguably to remember that good photography is good photography, and a good photograph comes (for the most part) from good photographic skills. Neither is dependent on the camera. It doesn't matter what camera you've got – it's you, the photographer, who conceives and shoots great photos.

Good advice, but perhaps a bit too naïve? It is true that a good photographer can take great shots on a middle of the range – or even a basic – camera and, conversely, investing in the most sophisticated kit won't automatically deliver great photos. There's no doubt however that having a good and capable camera will give you a head start and give you the option of shooting better photographs as your skills develop.

What do you want to photograph?

What you enjoy photographing and the way you like to use your camera will help determine the best camera for you. If you want a camera that you can use to record daily life or to take everywhere when travelling, you'd be advised to go for a compact, pocketable design. Don't confuse 'compact' with 'simple'. Compact digital cameras today range from simple point-and-shoot models through to those that would meet many of the needs of a demanding professional photographer.

If you've more ambitious photographic aspirations you might choose an SLR – a single lens reflex camera – sacrificing compactness for greater creative controls and the ability to interchange lenses. The option to change the configuration makes these cameras ideal for many varied types of photography and you'll be able to tackle (almost) any task. Great if you imagine your photographic aims will evolve with time. You wouldn't call these cameras compact and, price-wise, they're further up the ladder.

Over the next few pages we'll take a look at these options – and more – and examine the pros and cons of each. Then we can take a look at what to do when you've short-listed a few models and are ready to make the purchase.

Of course, this discussion makes the presumption that you are currently looking for a new camera, either to replace an existing film model or because you are taking up photography for the first time. If not, and you've already invested in a digital camera you still might like to scan through this chapter for some pointers to the key strengths and abilities of your chosen model.

The measure of quality

Before we look at specific camera types, it's worth getting to grips with the terms that camera manufacturers use to describe the effectiveness of a digital camera. Almost always the determining factor in describing the quality of images that a camera is capable of is the resolution. That is, the number of discrete elements (each of which can represent any colour, tonal or brightness value) that go to make up an image. The more of these elements (known as 'pixels', a slightly contrived contraction of 'picture elements') the greater the resolution. More pixels give scope for sharper, better defined images and also, should you need it, the ability to print to larger sizes.

Pixels and photosites: each of the millions of pixels on a camera sensor comprises photosites: light sensitive areas. In the case of this Fujifilm CCD close-up there are two photosites per pixel.

We can relate this to the world of conventional film-based cameras. For most of your casual photography, of the holiday snap type, you would be quite happy using standard, middle of the range film. These are the manufacturer's most popular film emulsions, often with a speed (or sensitivity) of ISO 100, and capable of producing good quality (if slightly grainy) prints. This was ideal – most of the photos you'd take with these films were destined to be passed around friends or stuck in an album.

When you wanted higher quality, for a special event for example, you might resort to a premium fine-grain film, such as the legendary Kodachromes and Velvias. Blow these up to a wall-filling 20 × 30 inch print – or more – and you'd still be hard pressed to find any grain. And, of course, for those really special photos you'd eschew your everyday camera for a large format model that, armed with the same film (and in the right hands) would be capable of exceptional results.

Today, most digital cameras boast a resolution of at least three megapixels (that is, millions of pixels) that is sufficient for printing to around A5 size or, in practical terms, slightly larger than a page of this book. Print sizes today tend to follow that of standard paper sizes. Referring this back to our film analogy, this would be equivalent to using the popular ISO 100 films. So long as you are not too critical, you will find (as I often do) that you can even print to A4 size. In fact, five or six megapixels is now becoming pretty much the standard in compact camera designs, giving more latitude for printing larger sizes if required.

For most users, a camera of 10 to 12 megapixels resolution would offer all of the resolution that they are ever likely to need. With this level of resolution you could print, should you wish, to A3 size or even larger. There is a practical consideration here though. Digital cameras record images on memory cards – removable and re-writable cards that are the digital equivalent of film. The larger the images (in

terms of megapixels) the more space they will take up on the card and, somewhat obviously, the fewer you can store per memory card. If you don't want to invest in a collection of memory cards (which, it has to be said, are not prohibitively expensive) and would be happy with prints to A4 size, a camera offering five megapixels resolution will be great for everyday use and for printing those occasional large prints.

Camera sensors: the part of the camera you don't see. Sensors come in a range of sizes and resolutions.

Note that I have been somewhat guarded in relating 'megapixels' with 'quality'. If our benchmark for quality were purely down to resolution then, clearly, the greater the resolution the greater the quality. Though broadly true, there are other factors, some more technical, that should be considered. How do the individual pixels respond to light? Can they accurately record a wide range of light conditions faithfully? And how faithfully do they represent colour? Some camera sensors use different pixel configurations or constructions to deliver better results; some, including many made by Fujifilm even provide two light sensitive points per pixel where one is optimized for colour, the other for brightness. This makes the cameras armed with such sensors particularly successful in recording shadow and highlight details in photos.

A better way to consider this is by another analogy, this time with a hifi loudspeaker. You could have a loudspeaker that has only a single speaker, charged with reproducing all the tones from the deepest bass to the most trill treble.

Or, for more authentic reproduction, you could invest in a loudspeaker that boasts two or even three individual speakers, each optimized for the reproduction of an individual frequency range. Just as the loudspeaker with optimized speakers delivers the best sound so a sensor optimized for different characteristics of an image should deliver the best images.

Resolution: viewed in extreme close-up, a high-resolution image reveals more detail than a low resolution one. In the latter, the pixel nature of the image is more obvious.

However, we risk getting embroiled in the detail here. As a simple measure (and certainly as a measure of relative quality) we can use megapixels as a benchmark.

Let's take a look now at the different camera types that you might have or be considering for purchase.

Compact cameras

Compact cameras are often described as being at the bottom end of the scale. That's increasingly something of a misnomer as even the most basic of digital cameras today are remarkably proficient and able to deliver good results.

Compact cameras tend to fall into two camps. The first are the auto-everything models. These cameras are light on controls, featuring little more than a shutter release – for taking the photo – and a few controls ranged around the monitor window on the back. This – I should add – is a feature of almost all digital cameras: a liquid crystal display (LCD) that displays the image through the lens letting you preview shots and review them after shooting.

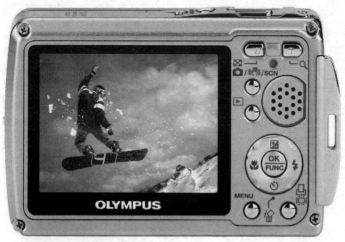

Compact, rear view: the large LCD panel on the back of compacts makes composing shots easy – though they can be problematic in bright lighting.

In these simple models, the camera itself takes care of all the controls – focusing, exposure and often the operation of the flash where required. You just compose your shot and press the shutter release. Creative controls are minimal but to deride these cameras for this would be missing the point. Many photographers are quite happy with point-and-shoot photography and these cameras are capable of great results under most conditions. 'Most conditions', but not all. So there will be compromises but, if you want a compact camera that is very compact, will deliver good photographs and one that you don't need to adjust the settings on prior to use they are definitely worth considering.

Because these cameras do bear the responsibility for settings and control they are not ideal if you want to take photos that are – even in small ways – out of the ordinary. If you want to focus on a specific element in the scene, make creative use of the lighting available or otherwise modify the look of a scene then you will need a camera that offers a higher degree of control. You will also find that auto-everything cameras do tend to only offer resolutions up to 5 megapixels – modest, but perfectly acceptable for A4 prints.

When you need a little more control there is an even wider range of compact cameras that offer everything from modest assistance through to fully manual control. Incidentally, virtually all these cameras will also offer a full auto mode too. That makes them perfect if you want to start by letting the camera take full control and then, as skills develop, graduate on to modes that offer more control.

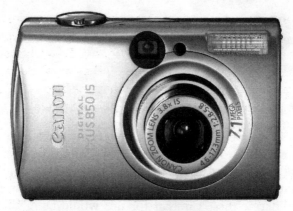

Compact cameras: many compact cameras may be small but most manage to pack quite a punch, in a photographic sense.

So what would these cameras offer that a simpler one would not? You can expect multiple exposure modes. We'll talk more about these later but essentially different modes allow you to set a specific shutter speed (for example) for that creative purpose and let the camera set a corresponding

aperture (that, for the uninitiated, is the opening of the lens). Or, conversely you can set an aperture and the camera will determine the correct shutter speed. You'll find these cameras will also have additional custom modes that configure the camera for best results when shooting action subjects, close-ups, portraits and so on.

Not exclusive to cameras in this class (many fully auto models boast one too) is a zoom lens. These will be familiar to many who have used a film-based camera though on digital cameras you do tend to find them offering more extensive zooming. With a zoom lens you can more accurately frame your subjects and they can help you achieve better compositions. You can also, of course, zoom in to more distant objects to have them fill the frame. Expect a basic zoom to allow scenes to be magnified by up to three times, and more powerful ones to offer up to ten times' magnification.

A word of warning: some cameras will boast a zoom ratio much larger and denote it a 'digital' zoom (to distinguish it from the conventional 'optical' zoom). Don't be seduced by the apparent power these offer. All a digital zoom offers is a way of enlarging a progressively smaller area of the centre of your imaging sensor. You gain magnification at the expense of resolution.

Camera phones

Mobile phones have boasted cameras for some time, although for many years the camera function was, if not something of an afterthought, a fun extra designed for sending impromptu low-resolution shots from one phone to another. As phone manufacturers vied with each other for customers in an ever more discerning market many of the initially frivolous features have matured, cameras included.

Cameraphones: no longer the poor relation, some cameraphones can be considered as a good camera with a phone attached, rather than a phone with snapshot capabilities.

Now many mobile phones can be regarded as much as compact digital cameras with a phone as phones with good cameras. A good camera phone will offer the same resolution and the same level of control as mid-ranged compacts. The more serious photographer who might consider a compact camera as a backup to their main camera tends to be a little sniffy about camera phones, largely on account of the mediocre photographic performance of early models, but that indifference is misplaced. Today, if you want a camera you can carry everywhere and don't want to carry it and a phone, they are definitely worth more than a second look.

Hybrid or 'bridge' cameras

The nature of digital technology – and in particular there being no need for a film feeding system – is such that camera designs do not necessarily have to mimic the established look of traditional cameras. This has lead to the appearance, and often the swift disappearance, of many eclectic and way-out designs. It's true that many compact cameras would

be indistinguishable from their film-based stablemates and likewise, SLRs (which we will look at shortly), but an intermediate class variously described as 'hybrid' or 'bridge' has survived. They've gained the description of hybrid because they have the look of an SLR – and much of the extended functionality that these designs offer – but are designed to be compact.

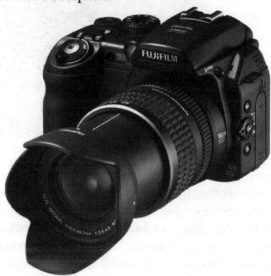

Hybrid cameras: ostensibly looking like an enthusiast's or professional's SLR camera, hybrid cameras are well specified and also well priced and compact.

What's the rationale for these cameras? Because many photographers want the simplicity of a compact – the all-in-one design, the simple-to-use philosophy – but don't want the same compromises when it comes to points such as the lens or the imaging chip. Hybrid cameras allow the inclusion of larger lenses (in terms of both the physical size and the zoom ratio). You will find hybrid models that range from simple point-and-shoot designs through to those that rival enthusiasts' SLR models in the control they offer. In the case of the latter all you will be sacrificing is the ability to interchange lenses.

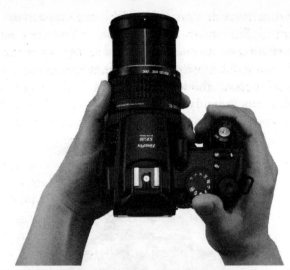

A firm grip: hybrid cameras make it easier (than compacts) to hold firmly
– essential for getting pin-sharp shots

It is true to say that hybrids are less popular now than they
were. The heyday of the hybrids was in the early days of
digital cameras when true SLR models were prohibitively
expensive. They were then definitely the preserve of the
professional. The hybrid allowed for the functionality and
handling of the SLR but, by using the then-cheaper
components common to the compact digital camera they
could be sold at a far more reasonable price. Now that
digital SLRs are offered at a wider range of specifications
and prices the rationale is less convincing. For many, though,
the size advantage – their compactness – is.

Single lens reflex (SLR) cameras

Watch professional photographers at a major sporting event
or catch a parade of paparazzi and you'll see that it's the
single lens reflex camera that's virtually the universal tool.
Just as with the film-based equivalent many professional
photographers adopt the SLR because of its versatility –

you can connect any one of a wide range of lenses – and the control. SLRs provide the ultimate in creative controls. As we've already noted it's not so long ago since the SLR would command a price premium that would place it out of reach for most enthusiasts. Thankfully, the proliferation of digital cameras and the widespread move to digital photography has resulted in many digital SLRs appearing at prices that make them affordable to most keen photographers.

It does tend to be the keen photographer and enthusiast (along with the professionals) that adopt SLRs because, along with the enhanced functionality comes added bulk. To carry an SLR around all day requires either very capacious pockets or a dedicated bag. Add in a couple of lenses and perhaps an additional flashgun, and it's clear that this is not the kit of the casual snapshooter.

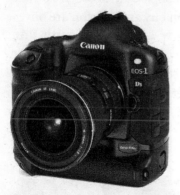 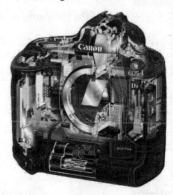

The single lens reflex: practically and technically the top of the photographic line and featuring a remarkable amount of technology within the body.

Like the other classes of camera, the digital SLR covers a wide range of models. As you'd expect, the more you pay the more features you can expect. As a general rule the higher up the model range (and price range) that you go the more advanced metering systems you'll have, along with a sensor boasting more megapixels and, not least, a camera that is faster. What do we mean by a fast camera? It takes

a finite time to transfer a digital image from a sensor to a memory card. If you're taking the occasional considered shot this is of little consequence. However the professional photographer who might be called on to get that perfectly timed shot at a sports event will be used to shooting film with a motordrive providing, perhaps, three, five or even ten shots a second from which an optimum shot can be chosen.

Digital cameras don't need a motordrive – there's no film to express through it – but need more complex electronics if they are to allow shooting at high speed. The mechanism is irrelevant to us here (for the curious they use memory buffers to store images as they queue to download to the memory card) but be aware that ultimate speed will come at a cost.

There's no doubt that when you buy an SLR you are buying into a system that can grow and evolve with your photographic skills. You will pay more than for other cameras and also you'll have additional costs when you want to add further lenses and accessories but for the true enthusiast, the SLR is the way to go.

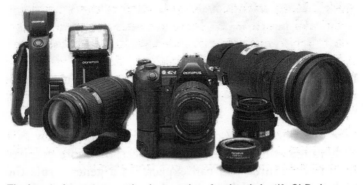

The heart of a system: enthusiasts and professionals justify SLRs because they can be customized to particular jobs using appropriate lenses and accessories.

Stills from movie cameras

If you own a digital movie camera you may have noticed that some of these offer still digital image recording. An alternative to a separate digital camera? No, not really. Digital video cameras are capable of good still images but the electronics and reproduction facilities in these cameras are optimized for moving images. If you find yourself without your digital camera and have a need to shoot some still images you'll get some good shots from your digital video camera but rarely will you get great ones.

Shopping for your digital camera

So, by now you will have made a broad decision over what type of camera is best for you. Now the fun starts as you can begin to study the models available and find that model that's a perfect match for you and your photography.

Where should you go for unbiased information on current models? Fortunately the popularity of digital photography has meant that there are a large number of monthly photographic magazines packed with reviews and rated guides. Many of these have associated websites providing additional information. These are often more up-to-date, able to report on the latest models yet to make it into print. A key benefit of review websites (and there are also many more that are independent of the press and are detailed at the back of this book) is that you can examine actual digital images produced by your short-listed cameras. You can therefore assess for yourself whether there are any shortcomings in the sensor design or whether you really need as many megapixels as you first assessed.

You could now follow the links on these websites and purchase your camera from an online store. Internet stores may offer the best prices but suffer from one major drawback: you can't try before you buy. Many aspiring

digital photographers have been caught out when buying online, finding that their dream camera is anything but a dream when it lands in their hands. That's why I recommend that you get your hands on all your short-listed cameras before making any commitment. Controls that look convenient and sensibly positioned when reviewed on screen – or even in a magazine – may prove to be anything but when in your probably different-sized hands.

Getting to grips with a camera even for a few minutes will also give you the chance to gauge how easy it is to access the controls and how well features such as the zoom and LCD monitor work in real-world situations.

Buying your camera

Now for the crunch moment: handing over your hard-earned cash for your camera. Should you go to an online store, or one of the traditional bricks and mortar variety? Canny shoppers always advise shopping online, pointing to a lower price for identical kit available at a higher price in the local shopping centre. However, today you need to be more circumspect.

Ask yourself a few questions beforehand. Is the price at the online store really for an equivalent product? When visiting a photo store you might find that the camera on sale there has a different range of accessories or a different warranty. Digital cameras are robust but a guarantee provides additional reassurance. Is it sourced from the local importer? Models originating from an overseas distributor may need to be returned there if a repair is needed under the warranty. Does the online store have associated 'real' stores or at least a real address? It's useful to know that there's somewhere physical you can go if you have a problem that can't be resolved by email or phone.

In truth, there is often very little difference in price between different store types and so the method of purchase will often come down to personal preference. As you would with any other shopping adventure, shop around and don't be afraid to ask for some freebies. A bigger memory card, a case or even an extra set of batteries.

Summary

Points to consider when purchasing a camera:

* Think costs and focus on models within your budget.

* Consider what you want and might want to photograph. If you've some photographic aspirations make sure that the camera will accommodate them.

* Do you have interests that demand a particular photographic type, e.g. macro photography for close ups of flowers, models or other miniature subjects?

* Is size important? Do you need a camera that will easily slip into a pocket or purse when required?

* How experienced are you? Do you aim to gain more skills and want a camera to match? Many cameras have fully automatic controls but allow you to turn them off.

* What do you want to do with your images – print large or send over Internet? If you plan to print large, for exhibition, you'll need a camera capable of high resolution.

* Talk to friends with cameras. Get their advice.

* Handle your short-listed cameras. What looks good on paper may not be so convenient to use in the hand.

* Shop around before purchasing. Internet stores don't always provide such good value as a local store.

* Keep an eye open for discontinued models. Last year's model may not boast the latest and greatest features, but the cost saving could be very significant.

02 accessories

In this chapter you will learn:

- about some 'essential' accessories that you'll need for your camera
- which other accessories can help you get better photos
- about which accessories offer good value for money and which don't

Photography can be compelling. Not only do you want to get out and shoot photos all the time, it's easy to be seduced into buying all those extras and add-ons that line your photo store's accessory racks. Suddenly, all that money you've saved on film by going digital – and more – disappears into an ever-heavier gadget bag.

Of course, this is part of the fun of photography. But, when it comes to accessories, how do you know what's good, what's bad and what's downright ugly? What should you regard as essential and what less so? Furthermore, what are downright frivolous? In this chapter I will examine the accessory market and give an assessment of all those vying for your attention.

Memory cards

Memory cards – along with batteries – are controversial accessories. Not because they are intrinsically contentious but because they should really be considered essentials. However, because when you go shopping you'll find them on the accessory racks (whether in a bricks-and-mortar store or an online equivalent) we'll consider them here.

When you purchase a camera it will come with a memory card. As the digital equivalent to film they are essential to getting your camera up and running. Often though, the camera manufacturers reward your faith in purchasing one of their models by providing a card with the most meagre of capacities and you will quickly realize that if you're likely to be shooting photos all day – or all through a holiday – the capacity is nowhere near enough.

Memory cards: essential to record your images, memory cards are widely available and cheap. There are lots of different types so ensure you get the right one for your camera.

Today, memory cards are available in a wide range of capacities and at a pretty economic cost. You might almost say cheap. For the price of a couple of rolls of quality film you can equip yourself with a high-capacity card. It makes sense to buy several before heading off on a long holiday or for an important event, much in the same way that you might once have bought a large supply of film. The difference, of course, is that once purchased you can re-use the cards subsequently, almost indefinitely. Unlike film – which (despite the dominance of digital cameras) can be purchased almost anywhere should you run out – memory cards are less common in some overseas markets (or off the beaten track) and somewhat more pricey when bought over the counter.

With cards available offering very large capacities (perhaps 8 or 16 gigabytes – the capacity of a computer hard disk not so long ago), should you go for one of these or several, smaller cards? I would recommend you opt for the latter. Memory cards have been known to fail. Though rare, a failure of just one of several cards would be annoying; the failure of your single high-capacity card containing your entire holiday or an important event could be catastrophic.

To give you an idea of how far your memory card will go, here's how many images you can store on different-sized cards for a 5 and 10 megapixel camera. Remember these are approximate figures and subject to variation according to the camera model and the way images are stored on the card. Different cameras compress the images for storage in different ways.

Camera	256MB	512MB	1GB	2GB	4GB	8GB	16GB
5MP	100	200	400	800	1600	3200	6400
10MP	50	100	200	400	800	1600	3200

Batteries

Just as essential, batteries are crucial in keeping your camera running. Not only are they essential they are, like memory cards, likely to run out at the most inopportune moment. So, along with the battery, or battery pack supplied with your camera, it makes good sense to invest in at least one spare set. Cameras vary extensively in the amount of power they consume and in the longevity of their batteries. Use the built-in flash significantly, or the zoom and focus controls, and the battery life could be shorter still.

The batteries that cameras use differ. Some use special custom batteries, often unique to that model. These are similar to those you'd find in a mobile phone. The good news is that they are rechargeable so you won't have to shell out for replacements very often. The bad news is that they are often expensive so purchasing a spare (or two) can be costly.

Many of these batteries are also available from accessory battery manufacturers that often provide them at a better price than the camera manufacturer themselves. Before purchasing one of these do check the capacity. They may be cheaper but it would be a false economy if through a lower capacity they were likely to last a far shorter time before needing a recharge.

Batteries: rechargeable batteries are a good way of keeping your camera alive – keep a second or third set handy to ensure you've always enough power.

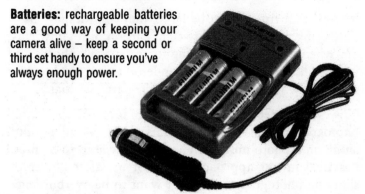

Other cameras use conventional batteries – usually in the ubiquitous AA or AAA sizes – and a set (usually recharge-able) are generally included when you purchase. The benefit of a camera that uses these batteries is that they will (in most cases) also happily accept standard alkaline equiva-lents and other disposables (such as high-capacity lithium); should you be caught out when your main rechargeable set runs out, replacements will be freely available almost anywhere.

Even so, it does no harm to equip yourself with a second (or even third) set of rechargeables. Even if you are not sold on the environmental benefits, the low running costs should win you over – a rechargeable set will cost little more than a set of good, high-capacity disposables and next to nothing to recharge.

Tripods and supports

Cumbersome and unwieldy. That's the disparaging way many camera users dismiss tripods. Sadly, for those who choose never to use a tripod, their slackness will show when they come to use their cameras in low light conditions or with a powerful zoom lens. Great photos need to be pin sharp. The slightest vibration can condemn to the waste bin a photo that would in all other respects be perfect.

It's true that tripods can be large, they are (despite many now being made from lightweight carbon fibre) unwieldy, but when quality is the driving force for your photos and you are likely to be shooting under extreme conditions – such as low light or high winds – they are essential.

However, we need a reality check here too. The committed photographer will have no qualms about taking a tripod along on a photo mission. The rest of us need to be more practical in our approach. Most of us, after all, enjoy shooting photographs but don't want to be overburdened

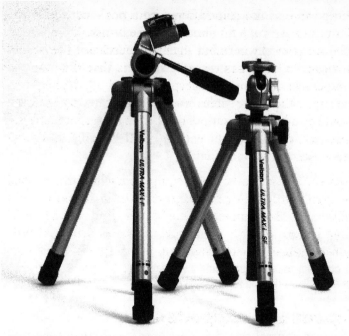

Tripods: tripods come in many sizes and weights. Larger, heavier models tend to be more rigid but even compact models like these will be effective

to the point that our days out are compromised. The good news is that there are a wide range of alternatives to the traditional tripod that strike a useful balance between portability and providing the necessary support.

Monopods: a tripod with a single leg. Brace this with your body and you've a pretty stable support. Of course it is not freestanding but the compact nature (the leg will collapse down to a short length) makes them easy to slip into a gadget bag – or to double up as a walking stick!

Beanbags: A beanbag can make for a stable support that you can mould, with your camera, to position your shot precisely. You will, of course, need some place to rest the beanbag (a wall, post or even the back of a chair) but again this is a great trade-off for a support that you can sling in a gadget bag.

Minipods: Shrink a tripod down to a pocketable size and you've the basis of a minipod. Like the beanbag you'll need to rest this somewhere but they give even more flexibility for directing your camera at a subject. Variations on the minipods include models that feature clamps (that can be attached to a convenient post or fence), spikes (that you can stick in soft earth) or bendable legs that can be wrapped around any handy object.

Minipod: a small minipod like this can be positioned by bending the legs. They are okay for compact cameras and camera phones but not sufficiently rigid for anything larger.

An increasing number of cameras – and more lenses – boast vibration control systems. These use digital or mechanical technology to reduce the risk of vibration transmitted from the photographer. They are very effective up to a point – allowing photos to be shot in borderline conditions where a firm support would be recommended.

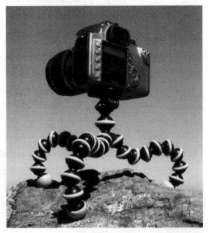

The Gorillapod: available in a range of sizes for compacts through to SLRs, Gorillapods have legs that can be positioned on rough ground or wrapped around a convenient support. They are well priced too.

Gadget bags and cases

How do you carry – or intend to carry – your camera around with you? Many compact cameras today are so robust and, well, compact that they can easily be slipped into a pocket when you are out for the day – convenient and always ready for action.

Still a pocket is not an ideal place for your camera and, if it's anything other than a small compact, impractical.

A soft case – as you might have for a mobile phone – is a good compromise. It keeps your camera protected from light knocks and abrasion yet adds little to the bulk. And you can always attach it to a belt or slip it in a coat pocket.

As you begin to shoot more and more photos you'll realize that you need a way of carrying not only your camera but also those extra memory cards, spare batteries and other accessories. Now it's time for a proper gadget bag. Get a good one and you've the perfect repository for those other things you carry around with you when you're out for the day – a phone and a water bottle, for example.

What bag should you go for when there are so many options? You want one that's large enough to take everything you need and a little more space for contingency. Don't go overlarge or you risk being encumbered.

Take care too that you choose a bag that doesn't shout 'expensive camera equipment'. It's sad, but safety needs to be prominent in your selection process. The good news is that there are lots of camera bags around that look quite innocuous and might easily be mistaken for picnic bags or baby bags. Whatever you go for, make sure it provides good protection and has lots of pockets to avoid all those accessories grinding around together at the bottom.

What about practicality? If you are in the process of amassing a large camera system – complete with heavy lenses

Camera bags: a traditional bag like this features custom compartments and allows a lot of equipment to be tightly packed.

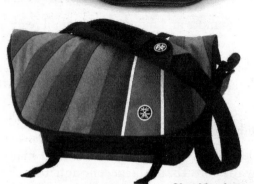

Shoulder bags: ones like this from Crumpler are innocuous – they don't imply that they contain expensive equipment – but have secure closures to hinder any light fingers.

Backpacks: the perfect option for the walker or rambler.

and other weighty accessories – you may have problems carrying the bag on your shoulder all day. Check out the alternatives. Backpack versions are good for walking expeditions or, if you are sticking to flat ground, a trolley, rather like aircraft cabin luggage, is a good alternative. You can wheel it around when the going gets hard.

Straps

Whether you choose to carry your camera in your pocket, compact case or a gadget bag, take it out and it becomes vulnerable. One slip and your valuable investment could be scattered across an unyielding and unforgiving pavement. It makes sense then to invest in a strap – and to use it as a matter of course. Many cameras come with a simple wrist strap (in the case of compact digital cameras) or a neck strap for SLRs. Both these are usually sufficient but you may want something more substantial or comfortable. For example neoprene shoulder and neck straps make the heaviest of cameras seem much lighter (and are ideal for extended use). A soft wrist strap makes for more comfortable use too.

Neoprene straps: these springy straps make even the heaviest camera feel lighter.

Shades and protectors

The advent of digital cameras with preview LCD monitors has introduced new problems for which the burgeoning accessory market has been keen to provide solutions.

Sunlight tends to obliterate the image on the preview screen and so you'll find a range of shades and protectors offered. These flip-up devices provide all-round shading for the LCD and reduce the risk of the screen being damaged should anything hit it in your camera bag. Of course, if you use the camera's viewfinder as a matter of course, this is one accessory you can safely neglect.

Filters

Now we are getting into more contentious territory. Time was when no self-respecting photographer would leave home without a large collection of filters. Screwed to the front of the lens, or slipped into a holder, they were essential for correcting colour casts, enhancing colour or creating special effects. Most of the effects a filter produced can now be achieved in a more controlled and more effective manner when we come to edit our images on a computer. So do we need filters today? Need? Perhaps not, but there's one that's still desirable and useful.

A polarizing filter is great for intensifying colour and reducing reflections. Cutting down on reflections is something we can't achieve digitally and can be important if shooting around water. Invest (and invest is the right word as good quality ones can be pricey) in a good polarizer that is appropriate for your camera. Ask advice from your camera store if you're not sure which one to choose.

Other filters? As your skills progress you may find a need for some others. Graduated filters for example, which allow you to achieve more even exposure when shooting bright skies and darker landscapes. But – and it's an important 'but' – there are some that you should steer well clear of. Special effects filters can fill your photos with synthetic rainbows, colour bursts and dominating spectral swathes. These filters – which also tend to be amongst the most

expensive – don't really make your photos better. What's jaw-dropping once becomes grating when seen a second time. If you really want to add absurd special effects to your photos you should do so later, on your computer. There, at least, if you judge the effect as too extreme you can remove it. Once burned on your image in camera it's there for good!

Flashguns

Almost every camera today, perhaps with the notable exception of some top of the range professional models, comes with an integral flashgun. Often diminutive, these are ideal for using in bright conditions to lessen shadows and for those impromptu indoor shots. Though powerful for their size, they are no substitute for an external flashgun. These provide the ability to light the darkest interior but more significantly, allow more control. You can, for example, angle the light to a ceiling to give more natural lighting effects and avoid obvious in-your-face (or, in-your-subject's-face) results.

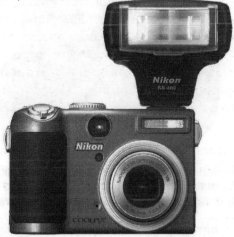

Compact flash: augmenting the in-built flashgun, accessory flashes provide greater power and more creative options when using.

Digital SLRs often have external flashguns that are closely matched to the features and controls of the host camera. This is ideal because you won't need to worry too much about setting the flash – the camera will take care of the control and the output for you. Even some compact cameras can now be matched with an external flashgun when you need that extra light.

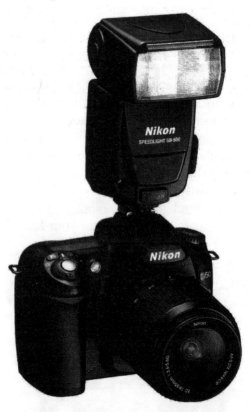

Pro flash: dedicated to SLR cameras, pro flash units allow maximum creativity and control and are pretty powerful too. Though offering full controls, day-to-day operations are managed by the camera itself.

Flashguns have their own set of accessories – filters, reflectors and diffusers – so beware in case your wallet takes a second knock!

Summary

In this chapter you have learnt:

• That some accessories are pretty much essential – have at least two 1GB memory cards (see if you can get one extra one with your camera as part of the deal), and at least one additional battery, or set of batteries.

• Which accessories are useful and which can – or should – be left on the camera dealers' shelves. Buy a good case for your camera and any essential accessories, and think seriously about buying a good support.

• That some expensive accessories are unlikely to justify your investment, but a few well chosen ones can repay you handsomely.

03 getting started

In this chapter you will learn:

- about the controls and features of your camera
- more about features specific to digital cameras
- about the digital approach to ISO and light sensitivity
- more about zoom lenses, flash lighting and macro features

So you've taken the plunge and got your new digital camera in your hand. If you've arrived at this point after a lifetime using conventional film cameras, you're going to have a sense of familiarity. The shape and the fundamental controls will be very similar to those of your old cameras. There's also a lot that's new too, so it makes good sense for us to start at the very beginning. That will give anyone who's new to photography a chance to get in at ground level too.

A tour of a compact camera

Here's a typical compact camera. If you've opted for a compact yours may not look identical to this mid-range model but, unless you've gone for a design that's particularly avant garde, most of the features will be similar and, in general, similarly positioned. Look for these key features.

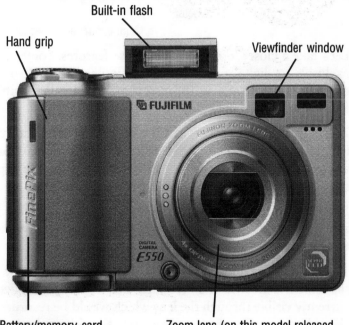

Built-in flash

Hand grip

Viewfinder window

Battery/memory card compartment

Zoom lens (on this model released by a button on rear)

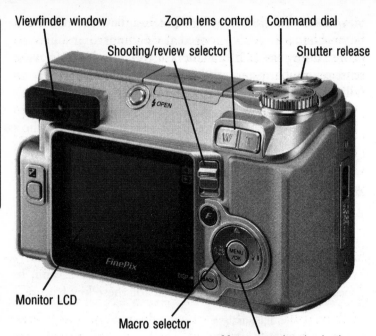

Viewfinder window Zoom lens control Command dial

Shooting/review selector Shutter release

Monitor LCD

Macro selector

Menu control and selection dial

Let's take a closer look at each of these features. Some are exclusive to digital cameras, others similar – though not necessarily identical – to those you may be familiar with from your film compact.

Zoom lens: When turned off, the zoom lens is retracted inside the body and protected from fingerprints, dust or any other damage by a cap. Turn the camera on, the cap retracts and the lens appears and configures itself for use.

In some camera models the on/off switch is incorporated into a manual lens cover. Retract the cover and the camera turns on. Close the cover and it turns off.

Viewfinder: The most prominent feature on the back of the camera is the LCD monitor panel that displays the image currently visible through the lens which would be recorded should we take a photo. Why then should we have a traditional viewfinder? It's often easier to use an optical

viewfinder and, in bright light, seeing the LCD panel can be problematic. Also, an optical viewfinder consumes no power. Using the LCD panel exclusively can run down the batteries much faster, so the optical alternative is a good fallback.

It's worth pointing out that not all models now feature an optical viewfinder. Put this down to brighter, more energy-efficient LCD panels that are making the traditional viewfinder redundant – and manufacturers' desire to produce more and more compact models.

Built-in flash: The diminutive flash unit you find on compact cameras packs a powerful punch and is ideal for those times when the light levels drop below what would normally deliver a great shot. On some models, the flash will operate automatically when the light levels fall. Others have auto flashing as an option. More sophisticated cameras will have additional flash modes – such as fill-in flash – to lighten shadows in bright sunshine and red-eye reduction to prevent those demonic eyes that appear in some flash shots.

Compact cameras aimed at the enthusiast end of the market may have a flash accessory shoe – as you might find on SLR cameras – that lets you attach an external flashgun to further extend your flash photography potential.

Hand grip: Though a tripod (or similar) provides the most stability, most of your shots will still probably be hand-held and so it's important to be able to hold your camera firmly and minimize potential shake. The handgrip to the right of many bodies allows for that. Furthermore, most grips double up as battery chambers and have space for the memory card too. If your compact does not have a hand grip, there's no need to panic – you'll just have to take a little more care when hand-holding your camera.

Shutter release: Press this to... release the shutter. In fact there is more to this diminutive button on the top plate of

the camera than merely releasing the shutter. When you start to press, you activate a chain of events that includes determining exposure, focusing the lens and priming the imaging electronics, all prior to the shot itself. You can depress this button half way to preset many of these so that you can shoot the photo more precisely. Many novice digital photographers have been caught out by the time it sometimes takes from starting to press the shutter and the shot being effected. With just a little practice you will, however, get the measure of it. Practice will most definitely make perfect here – and remember practice shots don't waste film!

Command dial: Unless your camera is fully automatic and offers no manual intervention, a command dial (or a similar selector) lets you select the most appropriate exposure mode for your photos. This may be Full Auto or Program (when, as you may recall, the camera makes all the decisions for you) or one of the semi-automatic modes. You may also be able to select one of several program modes for shooting sport, night scenes or portraits.

Here too, you may be able to select the movie mode. Most compact cameras can record short movie clips which are ideal for recording brief bits of video when you don't have a video camera to hand. A small microphone (in this case below and to the right of the main lens) records sound too.

Zoom lens control: Press W to select a wider angle of view, T (for telephoto) for a narrower, enlarged view. Some controls are pressure-sensitive: the harder you press, the faster the amount of zooming. Useful for fast adjustments and, with light pressure, precise framing.

Monitor LCD: This small screen relays the image that is currently being received by the imaging sensor. It provides a good, but not perfect, representation of the scene that would be recorded were you to press the shutter release. After you've taken your images you can review your shots

on the same screen. Using the selection dial (or sometimes the zoom control) when viewing images you can zoom into them to assess their sharpness.

Shooting/review selector: Switches your camera between a camera and an image viewer. Switch from the camera mode and you can use the LCD monitor to view the images you've shot. You can then reject (delete) those that you don't want to keep to free up space on your memory card.

Menu control and selection dial: Digital cameras can offer far more controls that a conventional camera. You can, for example, change the sensitivity – the equivalent of changing the sensitivity of film – from shot to shot. You could also add special effects as you are shooting or alter the colour balance. Rather than clutter the camera with all these additional controls as discrete buttons, you can use this control to access these features via a menu system.

Macro selector: Digital cameras, more so than their film based equivalents, are capable of shooting great photos close up. You can get really close by selecting the macro button. On this camera the macro selector is part of the selection dial but on other models you may find it has its own dedicated button.

Battery and memory card compartment: Here's where you can insert your memory card and batteries. A practical point – don't open this door or try to remove a memory card when the camera is switched on. There's a small but significant risk that you can damage the data on the memory card and, possibly, lose the images on it.

What won't you find on a digital compact? It's stating the obvious perhaps but you won't find a film compartment. That means that the back of the camera is fixed – so don't try to open it!

A tour of a digital SLR

The digital SLR has many of the features of its spiritual sibling the digital compact plus a few exclusives – designed to meet the needs of the serious enthusiast or professional user. Let's take a look. I have concentrated here on those features that differ obviously from those of the compact.

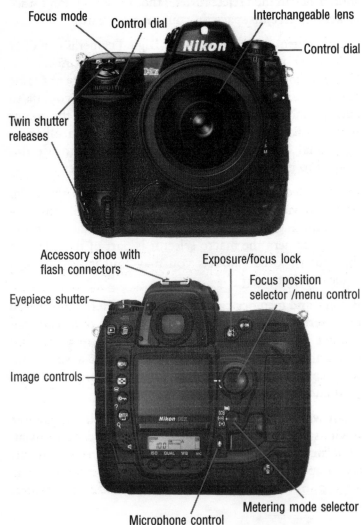

Focus mode Control dial Interchangeable lens

Control dial

Twin shutter releases

Accessory shoe with flash connectors

Eyepiece shutter

Image controls

Exposure/focus lock

Focus position selector /menu control

Metering mode selector

Microphone control

Interchangeable lens: The key feature that distinguishes an SLR (although there are a couple of premium compacts that offer the same) is the detachable and interchangeable lens system. As with a conventional SLR you can remove the standard lens and replace it with an alternative.

Twin shutter releases: Many (but not all) SLRs offer twin shutter releases. The operation of each of these is the same as a compact (for example, a half depression activates the focus) but an identical second release is provided to help when holding the camera in upright, portrait mode.

Control dials: Adjacent to the shutter releases, these dials allow modifications to the exposure. For example, you can change the shutter and aperture to different, equivalent settings (essential for full creative control of the camera).

Focus mode: Switch this to change the focusing mode: it can be set to continuous (when the camera will continuously focus so long as the shutter button is partly depressed), single (when the camera will focus once) and manual – where the lens may be focused manually.

Eyepiece shutter: Flip this lever and a small blind blocks off the viewfinder, preventing you looking though it. This initially perverse control has an important role: particularly if you're shooting using a tripod on self-timer (and there's no one behind the eyepiece) there's a risk that light will enter through the eyepiece and affect the exposure system. Closing off this route will ensure better exposures.

Focus position selector: on some cameras you can adjust the part of the scene the camera focuses on. If your subject is not central in the frame, off to one side for example, you would want the camera to focus on that subject. Conventionally the camera would focus on whatever was in the centre of the frame; this control allows off-centre focusing. This control can also be used, on some models, to navigate menus.

Exposure/focus lock: An alternative way to focus on an off-centre subject is to point the camera at it, focus, lock the focus then reposition the camera. You can press the focus lock button in these situations. The exposure lock button does the same for exposure – useful for when you want to take an exposure reading from a specific (non-central) object within the scene.

Image controls: In a compact, secondary controls can be accessed via a menu system, but the professional or semi-pro user often needs fast access to controls such as image delete and resolution. These buttons allow this.

Metering mode selector: Some compacts have multiple metering modes (again accessible through menu controls) but here you can switch between, for example, centre-weighted metering (a good all-round setting), spot metering (which meters off a small discrete element in the scene) and more advanced options.

Microphone control: Digital cameras append a great deal of data to the image file. This data includes camera settings, date, time and more, and only becomes visible when you review your images on a computer. However there may be some other comments that you want to make, for example, info about the location where you are shooting. A built-in microphone lets you append voice notes to images – or even use you camera as a surrogate voice recorder.

Accessory shoe and flash connections: The enthusiast or professional user is unlikely to be satisfied with a simple on-camera flash unit so the camera is provided with an accessory shoe for the direct fitting of an external flashgun and auxiliary connections for wired off-camera flash.

What you won't find on a digital SLR

It's unusual to find a movie mode. The rationale is that a professional will be concentrating on great shots and won't be interested (or have the need) for movie footage.

Another omission on the digital SLR are the special effects: designed to give your images a sepia tone, inverted colours, or no colour at all – black and white – these effects and more are common on compact filters. My advice is to give them a wide berth even if your camera does have them. You can apply similar effects later using image manipulation software on your computer – but you can't remove the effect applied to an image once it's recorded on your camera's memory card. Professionals have no use for these in-camera effects, hence their omission on digital SLRs.

More about pixels and sensors

It should be clear now that in terms of cameras there is much that is common between film and digital cameras. The key element that distinguishes a digital camera is the imaging sensor and this will be a good opportunity to take a closer look at this crucial component.

Without going too deeply into the physics, the sensor in a digital camera is, as I've already briefly mentioned, an electronic component that converts incident light into an electrical signal, a signal that can be interpreted as a digital image. The surface of the sensor is made up of a rectangular grid of pixels – each capable of recording the incident light and delivering a proportionate electrical signal.

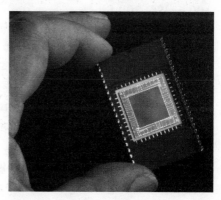

The imaging chip of a camera: though small, this particular chip is larger than those you'll find in most non-professional cameras.

When you review the specifications of digital cameras you'll not only see the number of pixels (megapixels), which define the resolution of the sensor but also the size of the sensor chip. In general, a larger chip is better than a smaller one (for reasons similar to those used for different sizes of film) because, even if the pixel resolution (that is, the number of pixels) on each is similar, the larger chip permits larger pixels with greater light gathering area.

Compact cameras tend to use small sensors whereas SLRs can accommodate larger ones. Most SLRs use chips similar in size to individual frames of APS film (normally 22 × 15mm) though some use larger ones equivalent to 35mm film frames (24 × 36mm).

You will also see a sensor described as a CCD or a CMOS. CCD stands for charge-coupled device and describes one type (and the more popular) of light-sensitive device. The other, less common one is the CMOS – complementary metal oxide semiconductor – favoured by some camera manufacturers because of its lower power consumption. Either is capable of delivering good images.

Sensors and sensitivity

When you buy film you opt for a specific light sensitivity, denoted as its ISO speed. You might, for example, use ISO 100 or ISO 200 film for general photography and ISO 400 or ISO 800 for photography in dimmer light. The higher the ISO the more sensitive the film.

Digital sensors work in a slightly different way but can be set to a specific ISO. You can, therefore take adjacent shots with significantly different ISO settings. Set the camera to ISO 100 for some sunny exterior shots and then ISO 800 when you step inside a building.

You can set the ISO in the same way that you would set any other parameters.

Does it make sense, then, to just set the camera to a high ISO to accommodate all shooting conditions? No. If you ever used high ISO films you'd have noticed that the higher the ISO the more grainy and contrasty images would become. Many photographers would use this increased grain creatively to add a gritty look and feel to images but for general photography this look would be unacceptable.

As you change the ISO setting of your camera you don't get increased grain but you do get the digital equivalent – electronic noise. Again without getting too technical, the more you try to capture an image under dim conditions, the more likely you are to amplify the random electronic noise in your camera. This noise is always there but, when the main image signal is high (as it is under bright situations), is of little consequence. When that signal is low the noise becomes more significant and affects the image. You'll see it as random colour fluctuations in shadow areas and graininess across the image. The message? Use the best (that is, lowest) ISO setting for your subject matter.

SLR lenses

For those who have invested in an SLR camera it's worth spending a few moments taking a look at the lenses you might choose to partner with it. If you already own a film SLR you may already have a collection of lenses that you might want to use with your new digital camera. Presuming that your new camera is from the same manufacturer and/ or it features a similar lens mount you'll probably find most lenses will be compatible with your new camera. Only some older lenses, that might not share the same contacts and connections as newer lenses, may not function.

It's worth noting that although you can use many of your traditional lenses with your new camera, the reverse – using lenses designed specifically for your digital SLR – is not

always possible. Because many digital SLRs use a sensor size smaller than that of 35mm cameras (the APS-C size) lenses designed for digital cameras don't produce a sharp image area sufficient to cover that of a frame of 35mm film. If you plan to use both old and new cameras you'll need to make sure that you choose fully compatible lenses.

It's also worth noting – if you have not done so already – that using a conventional lens with a digital SLR produces images of a different scale to those shot on a film SLR. This is a direct consequence of the smaller sensor size. Because the image is produced on a smaller area than that of 35mm film, the result is a magnified image, equivalent to one shot with a lens of longer focal length. This is why, when you use digital cameras (and this applies equally to the description of lenses on compact and bridge cameras) the lens focal length will be described in both absolute terms and in terms of a 35mm equivalent. So many of us have got used to the image scale produced with 35mm cameras, this has become something of an unofficial standard.

To convert the focal length of a lens with a nominal 35mm focal length to the equivalent you need to multiply it by

Table 3.1 Effective focal length conversions for 35mm SLR lenses used on a digital camera with a typical APS-C sizes sensor.

Actual focal length (mm)	35mm equivalent on a digital SLR (approx.)
50	75
35	52
28	42
100	150
200	300
10–20	15–30
70–300	105–450
24–200	36–300
18–125	28–190
80–400	120–600

between 1.4 and 1.6. The exact multiplier will depend on the sensor size but as a rule of thumb, multiply by one and a half to get a good approximation.

It should be clear from this that if you've some telephoto lenses, or telezooms you get a boost to their magnification through using them with a digital camera. This bonus comes at a price though – your superwide lenses will be similarly affected and be relegated to delivering only a modest wide-angle range.

Telephoto lens: able to capture a small detail of a scene or a distant view, telephoto lenses tend to be large and need to be properly supported to avoid vibrations.

This is a compromise that the lens manufacturers have recognized. Today you can find some very wide-angle lenses (10–20mm or 15mm) for example that would have been prohibitively expensive when engineered for a 35mm SLR. Designed for the more modest proportions of the APS-C sensor they become much more affordable and, dare I say it, desirable.

Wide angle lens: normally short and broad, wide-angle lenses (also available as zoomable lenses) let you include a much wider angle of view than a standard lens.

Lenses for compacts

As a footnote, it's worth mentioning that if you have a compact camera you can sometimes augment the standard lens with an accessory wide angle or telephoto. Doing so allows you greater opportunity for creative photography but compromises the compactness – lenses are often overlarge.

Accessory lenses for compacts: you can get some great shots with wide-angle and telephoto accessory lenses for compacts but the camera, with its lens converter, can no longer be considered 'compact'.

Practice

The great thing about digital photography as opposed to film is that you can practise using all the controls without wasting film. Better still, because you can see the results straight away the fruits of those proverbial labours can be instantly checked and monitored. If you've ever used film to trial different effects and different exposures, for example, and then waited for the processed film to arrive to see the results you'll recognize what a boon this is.

To make sure you've got to grips with your camera – in every sense – try the following:

1 Take some photos at dusk and see how low a light level you can use successfully while hand-holding the camera.

2 Do the same but set the zoom lens to its longest setting.

3 Change the camera's sensitivity – the ISO sensitivity – and compare the images. Look closely at the images and note how at high ISO settings you'll be able to shoot sharper images but at the risk of introducing some electronic noise.

4 Discover the focus lock and use it to shoot some off-centre subjects.

5 Use the fill-in flash feature to take some shots of people with the sun behind them. Shoot the same but with the flash off. Take a look at the difference.

Summary

In this chapter we've covered:

* The controls that you are likely to find on a typical compact and digital SLR camera. We've not looked at hybrid cameras, as they have virtually all the features of the compact with a few of those from the digital SLR.

* Some of the technical aspects of a digital camera.

* What a sensor is, how it works and its shortcomings – particularly in low light conditions.

* The fact that digital cameras are no more complex than film cameras and if you've gained familiarity with the latter, you'll quickly adapt to the digital model. If you've never used a camera before then you should quickly – and perhaps literally – get to grips with it.

04 your first digital photos

In this chapter you will learn:

- how to start taking photos with your digital camera
- how to preview your shots
- about reviewing your images
- how to make the most of the lens

A camera is designed to take photographs so, before we go any further, let's take a look at the process of shooting images. Then, armed with some digital images you'll be well placed to examine how you can transfer these images to your computer.

When you first acquire your camera, as with any other consumer electronics, you are probably reluctant to spend time ploughing through the manual to see exactly what your camera can – and can't – do. The good news is that to get going in digital photography you don't have to do this.

Previewing your images

The key characteristic of a digital camera, and the one that distinguishes it instantly from a film camera, is the LCD monitor. This, as we have already noted, serves several purposes. The first is allowing us to preview images prior to shooting. This is useful in that it shows a view pretty much identical to that which will be recorded on your memory card. The optical viewfinder does tend to be approximate – the position of the image recorded and the scale may be slightly different.

The benefit of the LCD monitor preview is that it allows you to hold the camera conveniently and easily assess the composition of your image and the position of subjects within it. You can even hold the camera in positions where it would not be easy to see through the viewfinder: close to the ground, for example, or above head height. Some cameras even have LCD panels that tilt and swivel to make their use even more convenient.

Mindful that the LCD monitor consumes a fair amount of power you can use the camera controls (either using push buttons, or selections from the on-screen menus) to turn the monitor off (so you will have to use the viewfinder) or to sleep after a specified number of seconds.

On some cameras, these same controls can be used to provide overlays on the screen. You can display a grid over the image to help in composition and to ensure you get vertical elements or horizontals squarely positioned.

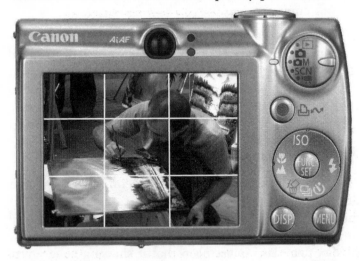

LCD monitor: the camera's LCD monitor is an essential compositional aid; you can augment it in many cameras with a grid overlay to aid better positioning of subjects in the frame.

The downside, as we've already noted, is that bright lighting and sunlight in particular, can wash out the image on the panel and make it almost impossible to use.

Previewing images on an SLR

Note that most SLR cameras don't allow previews of images. This is partly because the intended users of SLR cameras will prefer to use the viewfinder for its absolute clarity and the additional information presented. Also, the design of an SLR is such that the sensor can't see through the lens until the mirror (that directs the image to the optical viewfinder) flips out of the way. Therefore there's no signal to relay to the viewfinder until that point.

Some SLR cameras get around this by semi transparent mirrors but these are very much in the exception. The option of being able to use the LCD monitor to preview is less significant for these cameras.

SLR viewfinder display: SLR viewfinders can present a lot of crucial information, although not, as here, all at the same time!

Hybrid cameras, conversely, use the image on the sensor to feed both the electronic viewfinder and the LCD panel. Viewing controls let you select which is active at any time.

Shooting

Whether you choose to use an LCD monitor or a conventional viewfinder, the next step is to take your photograph. The mechanics are identical to any other camera.

Press the shutter release button gently until it is depressed half way. You'll hear the autofocus mechanism adjust to focus on the subject and you'll see the focused image in the viewfinder of an SLR or on the LCD panel. Press the button further to take your photograph.

That's all there is to it. If you take a quick look at the LCD monitor (and this includes digital SLRs that will display a post-shot image) you'll see your shot confirmed in the display. Take care when you're shooting to avoid camera

shake – squeeze the shutter release gently so that the camera doesn't tilt – a pinching action with your forefinger on the release and thumb below the camera will give the most stable results.

Safe shutter speeds for hand-holding a camera

If the shooting conditions are getting dark and the exposure selected – manually or automatically – is such that the exposure time will be too long for hand-holding you may get a warning – such as red light adjacent to the viewfinder or an amber one if the conditions are borderline.

Even if you don't get these warning displays, or the camera does not offer them, it pays to keep an eye on the exposure timing – if it's less than 1/60 second, the chances are you won't be able to hand-hold successfully. If you are using the zoom or a telephoto lens that time is significantly less.

Shutter speeds: getting the shutter speed right is crucial. When it becomes too long you will get unsharp – or blurred – shots like this.

The rule of thumb was that the slowest shutter speed that could be successfully hand-held was the reciprocal of the lens' focal length. So, if you were using a 200mm telephoto the minimum shutter speed would be 1/200 second; a 400mm telephoto, 1/400 second. The same rule applies for digital cameras except you'll need to use the multiplier discussed in the last chapter to work out the effective focal length. Hence a 200mm telephoto lens used on a digital SLR would require a shutter speed of 1/300 second or faster.

Remember when you shoot digitally you're not wasting any resources by being profligate. In fact, shooting more images than you would when using film is often to be recommended. Think of all those times when, using film, you've been necessarily thrifty and found that you wished – later – that you had shot more. Now you can shoot away to your heart's content.

Reviewing your images

Once you've taken a shot, it will be displayed by the LCD panel for a few seconds before the display returns to showing the current view through the lens, or going blank in the case of an SLR. You can make this post-view image appear for longer – or not at all – by using the camera's menu system.

To take a better – and prolonged – look at your images you can set the camera to review mode (using the shooting/review selector, see pages 36 and 37). Now you can use the forward/backward viewing controls (which are usually on the menu dial) to scan through your images. Because you may well have a large number of images you can also see pages of nine or even sixteen thumbnail images at a time and navigate around these, choosing which you want to look at more closely.

When looking at a photo you can zoom in to get a closer look. This is ideal for checking on focus or to check that all the subjects in that group photo have got their eyes open and have not been caught blinking.

Assuming you've followed our advice you'll have sufficient memory card capacity (on one or preferably more cards) to hold all the images you shoot but you can still delete any below-par images as you go along. That will save you a little time later when you come to download your images to your computer.

Summary

Hopefully now you'll have taken some photos and enjoyed the digital advantages including immediate review of images and being able to shoot at will without any regard for the cost!

Don't worry if your photos are not award winners. At this stage you need to develop a confidence in using your camera. What is important is to get the feel of it – to become familiar with the controls so that, when you need to, you can access a specific control easily. For that there is no substitute for practice. Spend some time taking your camera around with you and shooting prolifically.

05

basic photo technique

In this chapter you will learn:

- some basic guidance on photographic technique
- how to exploit the strengths and weaknesses of your camera
- some useful and simple tips for improving your photography

At the risk of preaching to the converted, so to speak, in this chapter we'll take a look at some of the basic (and let's face it, pretty simple) ways in which we can make photographs better. We can then overcome those problems that blight so many people's pictures.

Hold on

If there's a problem that afflicts more photos than any other it's a lack of sharpness. Sometimes this problem is negligible – it only becomes clear when you look very closely at your photos or print them to a large size. All too often, though, photos can be very obviously blurred.

The principal cause of blurring is, perhaps obviously, not holding the camera steady. We all do it: we think we can hold the camera firmly, avoiding shake, even when the camera suggests otherwise. Many cameras feature a warning light that will appear, or maybe flash, when there's an obvious risk of shake. In these conditions you need to take special care and, where possible, use a support of some kind. If you don't have a tripod with you, brace yourself against a support or rest your camera against a convenient wall or post.

Though it's in poor and failing light that we are most aware of the risk of shake, it's important to be mindful of it in any lighting conditions. Get into the good habit of holding your camera firmly and releasing the shutter gently.

Think about composition

Professional photographers follow some strict and formal rules on composition (of which more later) but even for our impromptu photos we should aim for a good arrangement of the elements within our prospective shot. What do we mean by this? It starts with being aware of the

scene in the viewfinder or displayed on the LCD monitor. It's easy to be distracted: to pay all our attention to the principal subject and scant regard to anything else in the scene. Instead, get into the habit of spending an extra moment or two looking around the frame.

If you're shooting a group of people make sure that all of them are in the frame and that no heads are cut off (a cliché, perhaps, but it's still surprising how often this happens, as the staff at photo labs will attest). Pay attention to the balance of the frame too. If your subject is in one part of the frame you may need something in the complementary part of it to give the shot balance. This is the basis of a powerful compositional principle called the Rule of Thirds, which we look at in more detail on page 97.

Missing head: it's easy to do; concentrating on the dolphin the photographer who shot this, took his eye off the ball – or rather the head – and cut off part of the subject's face.

Check the background

As part of your compositional checks, pay particular attention to the background. We've all seen (and perhaps chuckled) at those photographs that were carefully composed with regard to the subject only to find that, when printed, there's a tree apparently sprouting from the subject's head or some incongruous signage is visible in the background. Again it is easy to overlook such gaffs but think about backgrounds as you do your compositional check.

Fantastic shot? It was great until the fountain started up. We know it comes from the lake but any casual viewer might think the boy has a sprinkler system installed in his head!

As digital photographers we are better placed now than when we used film because we can, if it comes to the worst, manipulate and edit our images to remove any absurd elements. The fact that we can do this remedially, though, should not be an excuse for bad practice at the shooting stage – treat digital corrections as a last resort. Digital manipulation is all about making a good thing better, not rescuing shots that fall down due to bad practice!

Exploit your camera's zoom lens

Another of the characteristics that distinguishes the casual snapper is the way that subjects are often shot from a distance and left appearing diminutively small in the photo. The more experienced photographer will realize the importance of getting in close and letting the subject fill the frame. And if you can't get in close – then use your camera's zoom lens to get some frame-filling action.

Get in close: zooming in (or physically moving closer) to your subject gives them more impact. That really close-up shot (inner rectangle) is even more powerful, capturing every expression and wrinkle!

The power of so many photographs featuring people is getting in on the action and capturing expressions on faces. When subjects are mere specks in the centre of the photo this is impossible.

I've already given the advice that you should only use the optical zoom offered by your camera because using the digital zoom can result in lower resolution images. Don't be afraid, on occasions, to break this rule if you think you will get better results. The more you use your camera the more you'll get to understand what configurations offer the best results – for example, shooting using the digital zoom, or enlarging and printing the central area of an image.

Master your camera's focusing system

Apart from digital technology, one of the most profound advances in camera design in recent years has been autofocus. The assurance of getting sharp pictures every time did more than any other advance to get people out shooting photos at every opportunity. No more the disappointment of blurred photos, when focusing was neglected or the equally dispiriting results offered by the so-called 'focus free' cameras.

But autofocus didn't always deliver the expected results. And now, several years later, autofocus systems can still fool us. The problem is, autofocus is something of a dumb tool. Assuming conditions are favourable (autofocusing is still somewhat hit and miss in low light and with some high contrast subjects) the camera will focus on whatever it believes to be the subject of our photos. That may not, however, be our intended subject.

Consider a tourist shot with two friends standing in front of the Eiffel Tower. The friends provide perfect framing for the Tower and, in compositional terms, the photo is perfectly configured. However, the resulting shot reveals

Blurred subject: in this straight shot the camera has successfully focused on the sky and background, rendering the subject – who should be in sharp focus – blurred.

Blurred background: by first focusing on the subject, locking the focus and recomposing the view, the subject has been rendered in sharp focus and the background blurred. This technique is useful in emphasizing subjects.

the Tower in perfect focus and the friends as blurred and indistinct. No matter how practised, this is a problem we all experience from time to time.

The solution? Make it a rule to focus precisely on your subject first, and lock the focus by light pressure on the shutter release. Then recompose to take the photo.

Don't get too close – unless you switch to the macro mode for those real close-ups, you can find your subject is too close for the camera to focus successfully. Some will prevent you shooting in these conditions while others will advise you with a warning signal that can be easily overlooked.

Get the light right

Light is fundamental to photography – after all, in all photographs we are merely recording the world by virtue of the light emitted or reflected from our subjects. Trouble is, when it comes to photography we've been spoiled by our own eyes. Those eyes are remarkably adept at adjusting to light conditions that vary from the brightest noonday sun through to the darkest twilight. Our digital cameras too, can shoot across a wide range of conditions but without the same flexibility. Digital cameras work best when provided with plenty of light – colours will be rendered at their best and scenes will have a good degree of contrast. As the light levels fall and exposure times rise, the risk of camera shake increases (as we've noted) and, should you increase its sensitivity, there will be more background noise. Colour also tends to get muted as light levels fall.

That would seem to suggest that you should put your camera away when the light is not at its best. In fact, nothing could be further from the truth: some of the most evocative and intriguing photographs are taken under difficult lighting conditions. You just need to be aware of your camera's limitations and exploit its strengths.

The direction of the lighting

While we're on the subject of lighting it's worth noting the effect that the direction of the lighting on a scene can have. On a bright sunny day having the sun behind you can result in rather flat images due to the absence of shadows. Put the sun over one of your shoulders and you'll get a more pleasing, three-dimensional effect.

When the sun gets really high – and is almost overhead – you could end up with the problem of too much shadow: people's faces, in particular, can end up dark and shaded.

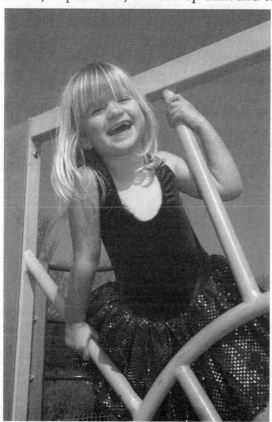

Fill-in flash: though bright daylight, the use of fill-in flash from the camera's flashgun has helped prevent the subject being rendered in shadow.

This is an opportunity for some creative flash photography. Select the fill-in flash mode on your camera's built-in flash and it will provide you with a discrete but sufficient amount of flash lighting to brighten these shadows but without adding noticeably to the brightness of the scene.

You'll need to use fill-in flash if the sun is behind the subject to avoid the subject becoming a silhouette. Having the sun (or any bright light source) shining into the camera can be problematic: if the light strays into the lens it can cause damaging internal reflections – flare. At best this will reduce the image contrast, at worst it will produce damaging reflections across the frame. Avoid this by either shading the lens with a well-placed hand or adding a lens hood. Alternatively shoot from a shaded position – under a tree for example – so there is no direct light falling on the camera itself.

Check the exposure

Exposure is critical – and for the most part you can rely on the camera to get it right for you. But, as your skills increase you'll be shooting under conditions that are more problematic for automatic exposure systems. You need to develop an eye for which parts of a scene you need to meter from and whether any reading taken from that point needs to be modified or compensated. Precise metering is a complex art but the good news is that cameras today (and sensors in particular) allow a bit of leeway. Modest errors can be corrected when we manipulate our images later.

The ideal area of a scene to meter from is a mid-tone area. Technically photographers refer to a perfect mid-tone as 18% grey because this ideal reference reflects 18% of the incident light. If you do get into situations where exposure might be problematic, here's a tip that could save many a shot. No matter what your skin colour, the palm of your

hand will almost perfectly match the reflectance of an 18% grey card. Take a reading off the palm of your hand and you can be pretty certain that you'll get a good – if not perfect – exposure.

Silhouettes: by taking an exposure reading from the sky, this produced a silhouette of this statue. If a meter reading were taken from the statue the much brighter sky would have been reproduced as bright white.

Exploit your camera's strengths ...

Shoot lots: digital photography costs next to nothing – you can afford to shoot extensively, covering all possible options. For example, if your camera has autobracketing, which lets you shoot three, five or more shots around the correct exposure, use it if the lighting conditions are difficult. The additional shots provide insurance and will ensure that you get one shot that is, in terms of exposure, spot on.

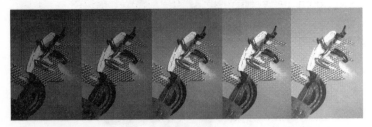

Autobracketing: the autobracketing feature in some cameras will let you shoot several shots at slightly different exposures; that can ensure you get a perfect exposure with at least one.

As well as shooting lots, try shooting from different positions, zooming in on details and pointing the camera in different directions. Look for patterns and juxtaposed colours. Many of your experimental shots just won't work photographically but be assured that some will be fantastic. Learn from these and add the techniques to your photo skills.

... and understand its limitations

Digital cameras – like any cameras – will have some limitations. You may find that the zoom ratio is not as wide as you'd sometimes like or the low light performance is not as hot as you'd like. Learn to live with these restrictions and adjust your photographic style accordingly. If the zoom isn't long enough for all occasions, use a bit of legwork to get closer; if the lens is prone to flaring around

bright lights, invest in a lens hood. But, overall, remember the camera is just a tool – you'll get your best photos through your own efforts and inspiration.

Be prepared

More so than conventional cameras, digital cameras can take a few moments to start up. Though shutter lag (the time taken between pushing the shutter button and the exposure taking place) in the latest cameras is negligible the start-up delay can still catch some photographers out. Turn the camera on and, not only does the lens unpack itself from within the camera body (in the case of a compact) but all the electronics take a few moments to start up.

Remember your camera electronics behave rather like a computer, albeit one dedicated to one specific task. As a computer has to boot up when switched on, so does your camera. You can avoid (or minimize) the problem of this down-time by keeping the camera on standby when out shooting.

Practice

To ensure you've picked up on the key points of this chapter why not try the following?

1 Get the feel of your camera's zoom lens: shoot the same subject but with the zoom lens set to different focal lengths.

2 Compare how the zoom lens gives slightly different results to moving closer or further away from a subject: shoot a scene with the zoom lens set to different focal lengths again but then move closer to the subject and take another shot. Even if the subject is the same size in both, the surroundings will be quite different.

3 Take shots of the same subject – such as a relative – from different directions when the sun is out. Notice how the lighting on the subject gives very different results as shadows become more or less prominent.

4 Use the same subject – if they are still compliant – to shoot portraits against different backgrounds. Notice how the choice of a background can have a substantial impact on the photograph.

Summary

Photography is both an expressive art and a recording medium. In either role it's not something that should be confined or restricted by excessive rules. The guidelines we've outlined here should not be viewed as compromising any aspects of your photography. Instead, many of the techniques should become part of your routine.

06

shoot better photos

In this chapter you will learn:
- how to shoot great photos in different situations
- about the best approach for different types of subject
- what to aim for and to avoid

In the last chapter we took a look at some of the fundamentals of good camera and photographic technique. It was not meant to be an exhaustive list but, rather, it was designed to offer a good basis from which to build your photographic skills.

The great thing about photography is that no matter what our interests, no matter what activities we enjoy, they can be captured on your camera. The enhanced flexibility offered by a digital camera extends our options further so here are some pointers on getting the best results no matter what your speciality.

Holidays and travel

What is the difference between holiday and travel photography? Well, travel photography is more about recording people and places whereas holiday photography is more about you, your family and friends at your holiday location. Pedantic? Perhaps, but despite the difference in emphasis, the way you approach the subjects and the photographs you'll take will be similar.

Whether on holiday or business, seek out different perspectives on your location. By all means shoot those standard tourist views but go for something different too. Don't neglect details. Now that you can shoot without worrying about running out of film you can shoot at will and record all those details down side streets and alleys – things that add to your memories of the place, emphasize local colour, but don't normally feature on photo itineraries.

Digital cameras can be a great icebreaker. If you find it difficult to approach and photograph local colourful characters, your digital camera can help – offer to show your subject the results. Language problems can disappear and you're likely to get a much more positive response.

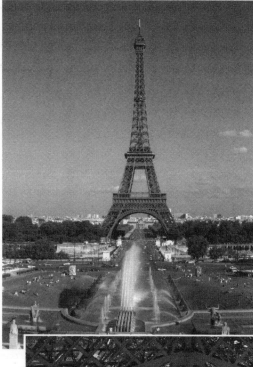

Eiffel Tower: (Top) it's a clichéd view perhaps but still makes a great shot. Don't let this be the only angle you shoot from. (Bottom) this view taken from the stairway is more intriguing and makes a great follow-up shot.

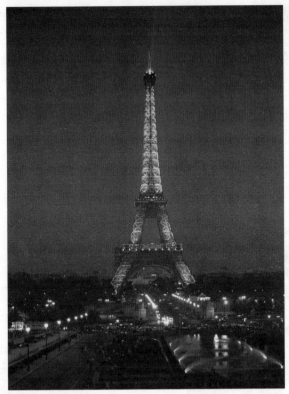

Eiffel Tower at night: taken from a similar position to the original shot, this dusk view shows the tower in, if you pardon the pun, a different light.

Shooting at different times of the day can also produce significantly different images even of the same subjects. Shortly after dawn, for example, you'll get a warm light and many popular locations will be free of the crowds that normally compromise photos. When it does get busy, later in the day, use the crowd constructively. Photograph tall buildings with people in the foreground looking up: in the final image, viewers' eyes are drawn up into the photo.

On a practical note, if you are visiting somewhere out of the ordinary and off the normal tourist routes do make doubly sure that you've all the memory cards and batteries that you need. You'll be unlikely to pick up any emergency

supplies along the way. If you're off on one of those once-in-a-lifetime holidays consider a back-up camera too.

What to aim for:

- New views and intriguing perspectives. Take a look at the postcard racks to get a head start on some good locations but don't be afraid to explore on your own (with due regard for safety, of course).

- Photographs of local people going about their business: these can often say more about an exotic or remote location than the landscape or landmarks – but do ask first before shooting close-up.

What to avoid:

- Mid-day in the tropics: the sun will be too harsh and, being overhead, will lead to poor lighting.

- Local faux pas: subjects that are top of the photo list in some countries – churches and temples for example – are strictly off limits in others. Check in advance if photography is allowed to avoid upsetting local sensitivities. And stay well clear of shooting anything considered a strategic or military installation!

Families and friends, fun and social

Social events and time spent with family and friends provide great photo opportunities. Think of all the time you spend doing things socially. Days out, parties, impromptu gatherings. All provide memories and those memories can only be enhanced with candid photos.

Weddings for example, are when you see almost everyone with a camera. Don't aim to emulate the professional photographer; go instead for the more informal shots and stages of the event that a pro is less likely to cover. The good thing about weddings is that they are colourful: an absolute gift to the photographer.

Weddings and social events: if there's a professional photographer at the event, don't try to get all the shots they would; go for the informal candid shots, that are often more meaningful.

What to aim for:

- Shooting lots: the more you shoot (or the more people shoot generally) the less intrusive the camera becomes and the more comfortable people feel.

- Storytelling: if you're shooting, say, a wedding or a party, rather than a collection of apparently random shots put some structure into your shooting agenda. Shoot photos at each stage of the event so that when you come to assemble your photos you can illustrate the whole 'story'.

- Close-ups: at social events people are generally more at ease and you can capture the expressions and emotions by zooming in close.

What to avoid:

- Stunted, posed group shots: our Victorian forefathers were into formal, staged portraits of friends and family. Today our lifestyles and approaches are much more informal and shots are regarded more meaningful if they capture people naturally rather than in a forced pose.

Portraits

The term 'portrait' covers a wide range of photographic styles from the formal to the informal and the candid. The formal portrait is one that is carefully staged: every detail of the lighting, the background and the person being photographed is carefully controlled to give the best results. There's also a tendency in the formal portrait for the sitter to adopt – or be asked to adopt – a less relaxed pose.

Informal portraits might still be carefully stage-managed but the emphasis on the pose this time is definitely very relaxed. The aim now is to capture the essence of the person rather than a strict pictorial representation.

Candid portraits tend not to be staged at all and are very much impromptu. These are great for capturing people in

spontaneous poses and rely on your camera's metering and focusing systems.

If your digital camera has a portrait scene mode, use this to save time configuring your camera: this will automatically set the aperture so that your subject will be in focus and the background blurred, reducing the risk of it causing any distraction.

Portraits: informal portraits are best at capturing personalities. Using a wide aperture blurs the background and makes the subject stand out.

You'll get the best results if you use the camera's zoom lens and set it to an intermediate setting – say about 1.5–2× on a compact (you can't normally be precise with a compact) or an equivalent setting of 80–110mm on an SLR. This modest telephoto setting will avoid the distortion you sometimes get when shooting faces at standard focal lengths.

What to aim for:

◆ Capturing personality: try to make your photos something more than a straight representation – leave these for passport photos.

◆ Good lighting: unless you need or want harsh lighting, make sure that the lighting of your subject is appropriate. You can use the LCD preview or even shoot some test shots first to ensure you get the best results.

What to avoid:

◆ Wide-angle lenses (or wide-angle range of your zoom lens): the result, when you fill the frame with your subject is a bulbous, unflattering look.

◆ Low angles: unless used for dramatic portraits (the look tends to emphasize the subject's importance) a low camera angle can be unflattering too as it can call attention to chins and tends to look up the subject's nose!

Landscapes and cityscapes

Landscape photography is very popular – not only do we enjoy shooting sweeping vistas, but it's a great way to boast about our travels. Good landscape photography, however, is always something of a challenge: too many landscape photographs make the mistake of trying to cram too much into a single frame. That sweeping vista tends to lose much of its impact if we can't relate to the scale.

So, the first rule is to include elements in the scene that can help anyone viewing the image determine the scale. Add

some foreground interest to lead the viewers' eyes towards the more distant scene or add some people.

Watch the lighting too. Too bright a sky above a dark landscape can produce poor shots: expose for the landscape and the sky will be overexposed and washed out; expose for the sky and the landscape will be in shadow. Remember too that the time of day will have a significant bearing on the look of your landscape: the interplay of light and shadow can dramatically change a single scene through the course of a day. We'll look later at how we can even out the lighting in scenes such as this.

Cityscapes: often the confined spaces in cities can prevent you getting everything into shot. The solution? Tilt the camera to get a diagonal composition. It gives you more space and exaggerates perspective and height.

If you live in, and spend most of your time in, an urban landscape don't feel short-changed. Urban landscapes and cityscapes can be as compelling to shoot as the more traditional rural ones.

Getting in close: a sweeping vista is a magnet to the photographer but the results can be disappointing: there's too much in the shot. Get in closer and shoot more detailed views.

What to aim for:

* Good lighting: lighting is crucial to getting the best from a landscape. When you find that super view, visit it at different times if you can, and under different weather conditions. Bright sunshine is not always the best shooting condition.

* Depth of field: this is good sharpness from the foreground through to the far distance. If your camera has a landscape scene mode, select this – it will configure the camera accordingly. If you use a camera with manual controls, set the aperture ring to a high number (say f16 or f22). At these settings the exposure will be long, so aim to use a tripod or support.

* In cityscapes, go for intriguing views, such as the reflections of one building in another or architectural detailing, as well as the more conventional shots.

What to avoid:

* Featureless foregrounds: if you've some dramatic hills and some pretty featureless fells in front don't go for the wide-angle view and try to capture everything in one shot. Instead wind up the telephoto and get close to the most dramatic features.

Action and sports

Unlike landscape photography where you can often take your time and be considered about your photography, action and sports photography demands fast responses and fast shooting. This time, events unfold before you and you have to ensure your photographic skills are up to the challenge. In fact, follow a few basic rules and, even if this is your first time you'll come away with some great photos.

Get into position early. At sports or other large-scale events getting to the venue early often gives you a better chance of finding the best place to shoot from.

If you've some experience of the event – even if you've not tried to photograph it before – use your knowledge to anticipate the action, so you and your camera will be well placed to shoot those vital moves.

Fast action: use your camera's zoom lens to get in close and pan – move the camera smoothly with the action – to keep the subjects sharp.

Get your camera prepared: typically the action will be some distance off so this is your chance to try out those long zoom lenses. Fast action also means fast shutter speeds are essential to freeze action. If your camera has a shutter priority mode, select this and then the fastest shutter speed that will still allow you to hand-hold (tripods can be problematic when using your camera on fast-moving subjects). Alternatively, select a sports or action scene mode to achieve pretty much the same result.

What to aim for:

• Pro sports photographers want to capture 'the decisive moment', that split-second shot that captures the essence of the event. It could be that crucial kick that scores the winning goal, the tennis player returning a powerful volley – it all depends on the sport. Professionals know when and where to shoot to maximize their chances of

capturing this moment; you can use your camera's (almost) unlimited shooting capacity to shoot multiple shots at crucial moments – hopefully one will repay you.

Wide angle vs. telephoto: you may get more in using a wide-angle lens (or the wide angle end of your zoom lens) but you won't see much. Better to go to the other extreme and zoom in close.

- Location shots: don't concentrate on the action on the field, or the road, or wherever. Add shots of emotive spectators, support teams or despondent competitors to make for good all-round coverage of the event.

What to avoid:

- Wide-angle shots: minute team members on a distant pitch say nothing and don't give those who will be looking at your photos anything to focus on. However, if the action allows you to get close, a wide-angle shot with a competitor up close can be very powerful.

- Using flash: in a word, 'don't' – it doesn't have the range. If the light levels fall, consider increasing the sensitivity (ISO). All those bursts of flashlight you see at sports stadia are doing nothing more than illuminating the heads of spectators in front of the photographer.

Nature and the wild

Wildlife, nature and even domestic animals make great photographic subjects but unlike human subjects, are rarely cooperative and often quite the reverse. Successful nature photographers will attest that most of their time is spent stalking their prey, often on a mission that results in no successful images. Though skill is crucial for those stunning wildlife photos, luck can play a major part too.

Patience, careful, slow movements and discretion are the key to getting a good photo opportunity with wild animals. For pets it's often the reverse – gaining their confidence and becoming familiar to them will get you in the best position to capture them (photographically, of course).

You can increase your chances of being able to shoot wild animals in your garden by putting out food for them. Hang bird feeders in your trees, put out nuts for squirrels.

Using your camera's zoom lens is almost obligatory for wildlife shots and often the longer the zoom the better. Similarly, unless it is crucial for a specific shot, you should ensure that the camera's flash does not fire (or will not fire automatically). The light will frighten most animals away.

Blackbird: with a modest zoom lens you can capture a wide array of wildlife from your own garden. This blackbird had been encouraged in using a handful of bird food.

Don't forget to go small too. With digital cameras' proficiency in the macro department, capturing small creatures – beetles, caterpillars and the like – becomes viable.

Honeybee: the impressive macro – close up – mode found on many digital cameras is great for shots like this. With the bee's attention focused on the nectar, it was easy to get in close and let the camera set the focus.

What to aim for:

- Natural looking environments: animals look best in their natural environment.
- Animals behaving naturally: you'll generally catch wildlife off guard doing what they do naturally but pet photos work best if you let them go about their daily business.

What to avoid:

- Bars and cages: zoos may be a great way to get close to wildlife but catching the cage or bars in the shot can ruin you photos.
- Distant shots: unless you want to show wildlife in its surroundings – that stag on a distant crag – you need to have any animals large in your frame.
- Distracting backgrounds: wild animals, by virtue of their nature and evolution, tend to blend in well with their

backgrounds. Try and capture them against a more contrasting backdrop or else get in very close (physically or by using your zoom).

Practice

Here are some ways of sharpening your skills – even if you don't have a holiday or a social event on the horizon.

* Shoot a theme: go out for the day – or an afternoon – and shoot as many photos you can on a single theme. That theme might be:

 * Subjects of a similar colour
 * Subjects of a particular shape
 * Similar subjects.

* Portraits: find a friend or a willing relative and shoot them on a trip out. Try to capture as many expressions or moods as you can; try also to avoid the subject becoming self-conscious.

* On your next day out try shooting a series of photos that tell a story. Make sure you get shots that portray each stage of the day. For example:

 * Leaving home
 * The journey
 * Arriving at the location
 * Going home
 * The aftermath.

* Shoot nature: get to know how you can shoot birds, insects and other wildlife. Work out how close you can get to, say, a bee, before it notices you; exploit the macro lens setting of your camera to get in really close.

To be honest there's no substitute for practice but follow the guidelines we've highlighted in this chapter and you'll

be well on your way to lifting your photography to the next level. Look on these as the fundamentals of good photography. In the next chapter we'll look at how you can further exploit the creative opportunities offered by your camera.

Summary

If you've been taking photographs for some time you'll have realized that there is more to taking a good photograph than pointing the camera and pressing the shutter. Different types of photography demand different approaches in order to deliver the best images. We looked at techniques for photographing:

* Holidays and travel
* Families and friends, fun and social
* Portraits
* Landscapes and cityscapes
* Action and sports
* Nature and the wild.

07

getting creative

In this chapter you will learn:

- how to shoot photos with 'wow'
- some important rules of composition
- some techniques that enhance composition

Have you noticed that many of your photos look good but some look great? You may have applied an equal level of care to all your shots but some seem to really grab your attention and cry out to be enlarged, framed or shared.

Why should some photos be so compelling and others less so? In some cases it's the subject. Think of that wedding portrait of a close friend or relative. A shot of a proud child at a concert or sporting event. Photos like these touch our emotions and draw us into the subject. These photographs can be technically imperfect and it will not matter a bit to those who will enjoy seeing them time and time again.

Other photographs score highly with us because, whether through design or luck, they are well composed. The structure of the photograph is such that, to use a rather imprecise description, it looks good. Sometimes (and surprisingly often as even professionals will attest) this is down to luck. But if you want to ensure that you don't have to rely on luck to get good photos you need to learn about photographic composition. Composition is important when conceiving all photographs; we can add good compositional technique to those emotive shots and you've some imagery to be particularly proud of.

In this chapter we'll look at some of the rules of composition. Rules? Isn't that a bit prescribed? Possibly yes, but these rules will improve your photography. Of course, like all rules, there will be situations when breaking them will lead to great images too. Our purpose here is to discuss them and their efficacy.

Composition is, in the broadest terms, about what you put into your photos and where you place them. It's also about how you position the camera with regard to your scene and your subjects. Composition is also what you leave out of your shots. Good composition produces good photos; great composition, great photos. Without wishing to sound too blasé it's as simple as that.

Selecting a format

Before we get to the point of looking at how elements in a scene can be arranged and linked together we need to judge which format will best suit our subject. Our notional choice is landscape or portrait. Landscape uses the camera held conventionally, with the frame of our image wider than it is tall. It's called landscape, as you might guess, because it's the format most often used to record landscapes. Similarly with the upright, portrait mode.

Don't feel, though, that you should ever take all your landscape shots in landscape mode or portraits in the upright mode. Much that you will learn about photographic composition is about judging which format works best with a subject when we take other matters into consideration.

The reason that we might shoot a portrait in the portrait format is that this format allows us to fill the frame with

Selecting a format: this image works well in portrait mode where we can concentrate attention on the dancer's pose and expression. It would also be successful in landscape, as we could see some of the surroundings.

our subject and waste very little space on the surroundings. Viewers are therefore drawn to the subject and not distracted by the background. Sometimes, however, we may want to show a person in context, in which case the landscape format might be more appropriate. This provides us with more space on screen and we have to be careful and consider how we fill that space, as the last example suggests. Of course, if our subject is sitting or reclining, landscape mode may be the most suitable format in any case.

Landscape format: shooting in landscape mode shows us the sweep in this bay but switching to portrait mode gives a quite different composition of part of the original scene.

The choice of format can be equally problematic when shooting landscapes. Many photographers will resort to landscape format when shooting landscapes and do so exclusively. But, just as some portraits can be more powerful in landscape mode so some landscapes will work best in portrait.

Diagonal compositions

When we describe a shot as being portrait or landscape we make the presumption that, within either of these frames we will have subjects that broadly follow convention: vertical lines will be upright, the horizon horizontal across the frame. You don't have to shoot this way though: sometimes a shot with a diagonal or tilted composition can lead to a very powerful image.

When might we use a diagonal composition? To emphasize height for example. Tilting the camera so a tall building crosses the diagonal makes the shot more dramatic. Also, when you use a diagonal composition you can often capture tall objects that you would have a struggle to accommodate in the frame when shooting in a conventional portrait format.

You do need to exercise a little caution. Your shots need to be very obviously tilted, using the full diagonal of the photo frame, otherwise a more modest tilt may simply suggest to anyone viewing your images that you have not held the camera squarely!

Placing elements in a scene

How we place subjects – and other objects – in a scene has the most significant effect on the composition and the ultimate power of the image. Let's take a look at two contrasting methods.

Diagonal composition: by tilting the camera, this shot of Big Ben is not only more dramatic but the photographer has succeeded in including more of the tower than would have been the case if shooting in portrait mode.

Symmetry

With different subjects, symmetrical placement can be a powerful way of arranging subjects or one that is intensely boring. Symmetrical compositions that work best tend to be those that are so overtly symmetrical that the subject looks almost like an object and its mirror image.

The architectural shot shown below is a case in point. Though it is clear this is a straight shot, almost every detail on one side is mirrored on the other. The strength of this image is due to the very strong symmetry coupled with the powerful converging lines.

Symmetry: the striking symmetry of this building and its grounds makes for a very powerful image. If the symmetry or the converging lines were not so strong the image would be less convincing.

Portraits shot with symmetry in, say, the background, are less impressive. A viewer's eye is drawn immediately to the subject and then their eyes wander, somewhat aimlessly about the scene.

The rule of thirds

This is one of the few firm compositional rules but it rewards your compliance with some really good photos. The rule begins by telling us to divide our images into nine equal rectangles by drawing two equidistant horizontal and vertical lines. In fact, this rule is considered so important as a compositional aid that many digital cameras provide the option of overlaying the corresponding grid on the LCD monitor panel to aid in composing shots.

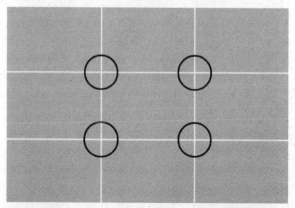

Rule of Thirds: important subjects should be placed at the intersections and boundaries (like the horizon) along the respective lines.

Four points are created at the intersection of the lines and it is upon these that important objects and the subject of your photos should be placed. You don't of course need to put an object at each of these intersections and applying the rule of thirds is often a case of placing subjects and objects in a more logical way than you might otherwise have done.

Powerful implementations of the rule happen when you can provide two complementary elements in diagonally opposed intersections (sometimes called sweet spots or power points). You can also often improve those weak symmetric portraits by moving the camera position slightly so that a subject aligns with one of the vertical lines.

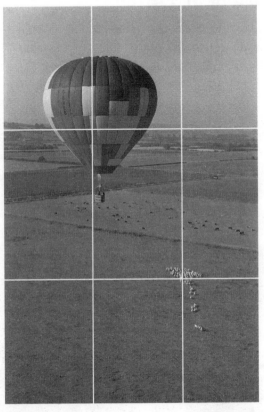

Rule of Thirds (2): here the strength of the composition comes from the placing of two complementary subjects – the balloon and the cattle – at opposite intersections

You can partially apply the rule of thirds. For example, for that stunning sunset shot you might place the setting sun pretty much centrally in the frame, but the horizon along the lower horizontal line.

You can also use the rule of thirds to draw a viewer into a photograph. By placing a foreground object at, say, the lower left intersection and a more distant subject at the top right, the foreground object leads the eye through to the subject.

Look up, look down

We tend to point our cameras horizontally when shooting the majority of our photographs. There's nothing wrong with this and in some situations, it is essential (for example in architectural photography). Unless we are after dramatic effect, tilting the camera produces converging verticals, making the building appear too narrow or even to be on the brink of toppling. However, pointing our camera upwards or downwards can produce some interesting and sometimes intriguing images.

Pointing the camera upwards when you shoot a portrait can sometimes emphasize (in an unflattering way) chins and give too much prominence to the nose. We can, though, by adopting a very low position, produce portraits that impart a sense of power or confidence to the subject. Have your subject adopt a stern look and you can use this compositional tool to suggest dominance and even to become intimidating.

Looking up: pointing the camera upwards produces a portrait which suggests enhanced confidence, as in the case of this young person.

A low angle can also impart a sense of power to inanimate objects compared with shots of similar subjects from more conventional viewpoints. This low angle shot, with the camera directed upwards slightly, is much more powerful that one taken from eye level or even waist level.

Angling the camera downwards has the opposite effect: the suggestion here is of inferiority and, depending on the subject, an expression of vulnerability.

Looking up and down at even more extreme angles can produce equally powerful shots. In the spiral staircase photo, the camera has been pointed down the stairwell of a lighthouse. Not only does it make for a dramatic shot it also emphasises the spiral pattern. Though everyone who explored this landmark may well have taken a glance downward it is only when the image is recorded photographically that the stark geometry becomes clear. Similarly we rarely look over our heads as we walk around. Doing so can often pay significant photographic dividends as very conventional subjects take on a more dramatic and unusual appearance.

A downward shot gives a dramatic view of this spiral staircase.

Framing your subjects

When you look at a picture your brain prompts your eyes to find the subject. We use compositional tools and rules to aid this and, in a sense, give our eyes a short cut. Frame your subject, perhaps using a doorway or something less

formal like the branches of trees and you give your eyes a head start. We seem to be instinctively drawn into a frame and our attention is drawn to anything within that frame.

Overhead: pointing a camera overhead is something we rarely do but, get the timing right and the results can be impressive. Here the photographer has not only caught this balloon passing overhead but also positioned the camera according to the rule of thirds.

Gateways, doorways or less formal arrangements such as this tree can provide framing that helps focus our attention of the subject within.

Using lines

After frames, lines play an important part in photographic composition. We've already seen how they enhanced our symmetrical composition and emphasized diagonals. More informal lines are useful in leading your eye towards the subject and might comprise something as potentially bland as fencing, a roadway or even architectural elements. These

lead-in lines (so called because they lead the eye into the photograph) need not be straight. Often a sweeping curve or a flowing 's' can be equally compelling.

The power of lines: these tall, slim cooling towers are strong vertical elements that emphasize (and to a degree frame) the subject, the avant garde communications tower.

Lead-in line: shot from the underside, it is the curvaceous line of this bridge roadway that leads our eyes to the central span. Again this, the subject, is placed according to the rule of thirds.

The roof line here leads our eye to the central dome.

Subject lead-ins

Moving subjects need to be seen to be moving in towards the centre of the frame. Again, you will probably find that instinctively you will place a moving object at the centre of the frame. You need to overcome this desire and point the camera just ahead of the movement.

Lead in (top), lead out (bottom): with moving subjects ensure that the subject is always heading in towards the centre of the frame and not (unless there is a very good reason) leaving it.

Depth of field

When shooting photographs we generally take care to ensure, as we should, that the subject is in sharp focus. As a consequence we will find that parts of our scene that are in front of the subject and parts behind are also in focus. The range from the frontmost element through to the most distant that is in sharp focus is called the depth of field. You can vary the depth of field by changing the lens aperture. The wider the aperture, the shallower the depth of field. At the widest setting only your subject may be in sharp focus. At very small apertures you may find everything, from the objects closest to the lens through to the furthest point from the camera, are sharply defined.

Sharpness is something that we should treasure but allowing those parts of the scene in front of and behind the subject to become blurred can work well in ensuring attention is, literally, focused on that subject.

You will find as you become more experienced that with telephoto lenses, depth of field tends to be very narrow in any case. So, when shooting a portrait at a modest telephoto zoom ratio, your subject's background will be blurred (as I mentioned in the last chapter with regard to portraits). You can increase the blurring by opening the lens aperture further (by, as you may recall, selecting a numerically smaller f stop). Wide-angle lenses, conversely, have wide depth of field and you may struggle to get a sufficient differentiation between subject and background even at wide apertures.

As I mentioned earlier, if you are using a compact camera or an SLR with similar controls, selecting the portrait scene mode should automatically configure the camera to provide sufficient depth of field to isolate a subject from the background. Though described as 'portrait' this scene mode can, of course, be used for any subject you wish to isolate from foreground or background distractions.

Emphasis using depth of field: using a relatively narrow depth of field can help isolate a subject from the background.

Trimming and cropping

Here's a compositional tool that's more a rescue remedy than a rule. It's something you can use post-shooting when you come to manipulate your images on your computer.

When the advice 'get in close' is given there's the risk that you can get in too close and trim away some of the crucial elements of an image. It becomes all too obvious when we

accidentally cut off the top of a subject's head but less obvious trims – the subject's feet or an arm for example can also compromise your shot.

Fortunately digitally we have a fallback position. When we come to edit our images on the computer we can alter the original crop (that dictated by the original framing of

Cropping: the image manipulation cropping tool lets you recompose images after you have shot them, changing the subject position or trimming away superfluous elements.

our image) to something that is compositionally stronger. Of course, for this to be successful or even viable you will need to have shot the original images and been a little liberal with the space left around the subject.

The cropping tool lets you define the new edges of the print and alter then as you wish, observing the effect on the image and the composition. The good thing about this technique is that you can experiment at will, without applying the crop. Only when you are totally satisfied with the result do you need to commit (and, because you can work on a copy of the image, you won't compromise the original).

Practice

Here are some examples for you to try:

* Exploit the Rule of Thirds. Try these example shots to understand the potency of the Rule of Thirds.

 * Shoot an obviously posed subject in the centre of the camera's viewfinder. Now move them to one side, in the position suggested by the Rule of Thirds. Is the result more powerful?

 * Shoot a conventional sunset, then another with the horizon along a Rule of Thirds line. Compare them.

 * Try to compose a shot with subjects at complementary intersections (as in the hot air balloon photo).

* Symmetry:

 * Look for symmetry around you and shoot some symmetrical compositions.

 * Try shooting some photos symmetrically and others using the Rule of Thirds. Which look most powerful? Can you see why?

* Diagonal compositions. Get up close to tall buildings (church spires and towers work well for this) and shoot

some diagonal compositions. Shoot some square-on shots too and compare them. How far away do you need to shoot from to get the whole building in? And which shots have the most impact?

• Depth of field. Shoot the same subject (which can be a person, or an object) using a wide aperture (if your camera allows you to set one) and a smaller aperture. Notice how in the first shot the subject will be set against a blurred background. That concentrates attention on the subject. If your camera doesn't allow control of the aperture try setting different scene modes (portrait and landscape) for example, for a similar result.

Summary

Getting great photos depends on several factors:

• Good command of your camera (whether it's a point-and-shoot or the latest top-flight SLR)

• Interesting subjects

• An understanding of the key competences that go to make a great photo.

Follow these rules and you can't guarantee every shot will be a winner (just remember that professional users discard more images than you or I ever will) but will ensure the standard of your photography will rise. And among those shots will be some prized greats. Cherish them. You've worked hard to get them.

08

using flash

In this chapter you will learn:

- how simple it is to use flash to improve your photos
- about different types of flash lighting
- how to exploit different flash modes

Flash photography is something that many photographers regard – if it is not an oxymoron – as something of a black art. Some photographers shy away from ever using it and others make minimal use, and demonstrate a very poor understanding.

Historically this might have been justified: flash lighting had long been unpredictable and difficult to control. Cameras – and photographers – were often held to ransom by the flashgun rather than the flashgun proving to be a welcome addition to the photographer's kitbag.

Today you should have no such fears. Even the most basic camera features a well-tamed flashgun that will faultlessly perform on demand. Indeed, on many cameras the flash will work discretely without prompting to provide that extra bit of lighting when things get a bit dim. The more sophisticated the camera the more sophisticated the flash capabilities. Don't mistake sophisticated with complicated – much of the sophistication is concerned with making the flash a useful adjunct to your photography with minimal effort on your part.

Flash modes

Like your camera's exposure modes, the electronic flash system has a range of operational modes that we can summarize as:

- **Direct flash:** a burst of light to supplement available light. This is what all flash units – in-built or external – offer.

- **Fill-in flash:** a carefully balanced amount of direct flash for brightening shadows in light conditions.

- **Bounce flash:** flash used indirectly, bounced off a convenient reflector, to give less harsh lighting.

- **Slow sync:** a flash burst combined with a slow shutter speed.

- **Front-curtain sync:** in cameras that use a focal plane shutter (generally SLRs) the flash fires immediately when the shutter is fully open. This is the normal operational mode for flash in cameras with this type of shutter.

- **Rear-curtain sync:** similar to front-curtain sync but the flash fires immediately before the shutter closes.

- **Stroboscopic mode:** the flash will operate several times (2, 4, 8, 16 or sometimes more) during the exposure.

- **Multiple flash:** using two or more flash units simultaneously.

Generally, flash modes lower in the list above are found in more sophisticated cameras, and some, as mentioned in passing, are only available in SLR systems. Let's take a closer look at these modes

Direct flash

When you shoot a photo and the camera automatically senses that flash is needed and fires it for you, that's direct flash. The light from the flash leaves the camera and directly illuminates the subject. Simple and effective, the chief attribute of this lighting mode is that it can deliver the full power from the flash to the subject. Because you are directing the full intensity of the light from the flashgun at the subject you are using the power of the light to the full. No light is wasted and you'll get the greatest range from your flash when using this mode.

Does this create any problems? Yes. As direct flash does fire directly at a subject, the lighting effect it produces tends to be very harsh, casting very little in the way of shadow (except for that behind your subject). This gives very flat lighting – your images have very little apparent depth. Also, the light intensity falls off with distance according to the inverse square law: the flash illumination of a subject twice the distance of the principal subject will be one quarter,

and hence substantially dimmer. If you are photographing a group of people using direct flash you'll need to ensure that they are all at approximately the same distance from the camera.

Direct flash can also cause red-eye. This is the bane of many photographers' lives, particularly those who enjoy shooting at parties and social events. When a flashgun is very close to the lens the light from the flash can reflect from the back of the subject's eyes (and eyes whose irises are already opened wide by virtue of the low ambient light levels). What the camera records is the reflection of light from the fine blood vessels on the retina – a bright red demonic glow.

Direct flash: harsh shadows and, in this case, red-eye are the result of using direct flash.

One solution proffered by the camera manufacturers is to incorporate red-eye reduction pre-flashing. The flashgun will emit a series of low-level flashes prior to the main shot with the intention of prompting the iris in the eye to close down. It's rarely any more than modestly successful and the couple of seconds' preflashing doesn't make for successful candids!

Fill-in flash

Sometimes called simply fill flash, this is a flash mode that you would use on the brightest of sunny days. That comes as something of a surprise to many people. Why, when you have the strongest of lighting sources available to you, would you want to use flash as well? It comes down to direct sunlight often being too strong and too harsh: parts of your brightly lit subjects can also be heavily shaded. When photographed, the contrast between bright and shaded areas will become more pronounced and not deliver the best image.

Fill-in flash: bright sunlight produces intense colours and vibrant shots but also shadows. Fill-in flash can overcome this (courtesy Lastolite).

Fill-in flash delivers a carefully controlled amount of direct flash. This is sufficient to lighten the shadow areas but not so bright that it becomes obvious that a flash has been used. The calculation of the amount of fill-in flash required is done by the camera, so all you need to do is select this mode (either from the camera's menu system, or the flash button) prior to shooting.

You can also use this flash mode where you have a subject that is in virtual silhouette. For example, if your subject were standing or sitting near a window, with a bright scene behind, conventional exposures would either produce a well-exposed shot of the subject with an overexposed background or, conversely, a well-exposed background and a dark silhouetted subject. Presuming that, creatively, you wanted neither of these, activating the fill-in flash mode would provide a complementary amount of light to capture both the subject and the background at optimum exposure.

Bounce flash

Bounce flash is normally the preserve of external flashguns because now we are not going to illuminate the subject directly – as will always be the case with fixed, on-camera flash units – but indirectly.

As you can probably guess from the name, bounce flash involves bouncing the flash light from a reflective surface so that the reflected light illuminates the subject. This is perfect for giving more even illumination and also avoids the risk of harsh shadows.

When you set a flashgun up for bounce flash you will point the adjustable head of the flashgun upwards so that the flash will fire at, say, a white ceiling. The light then reflects back and illuminates the whole scene in front of the camera.

There are a couple caveats in bounce flash photography. The first is that it assumes you've a convenient surface to

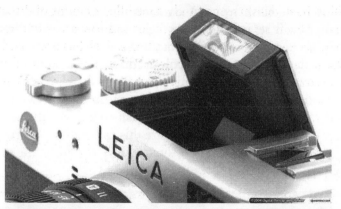

Bounce flash: top-end compact cameras feature pop-up flashguns that can be angled upward (as well as the more conventional forwards) to produce bounce flash effects.

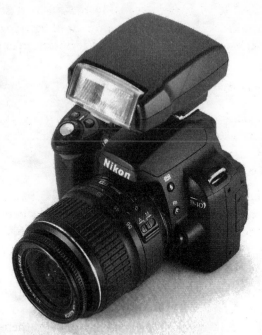

Bounce flashgun: the head – or the flash unit – of an auxiliary flashgun can be tilted upward at a number of different angles for different bounce effects and to correspond to a range of subject distances.

bounce the flash from. A dark ceiling (or wall, for that matter) will reflect much less light and the reflected light may be insufficient to illuminate the scene. Also, should the reflective surface be coloured, this can impart an unwelcome (or at least unintended) tint to the lighting. Second, even with a good reflective surface, light will be lost. Add this to the increased flash-to-subject distance (because we now have to measure this as the distance from flash to reflector and reflector to subject) and again the light levels could be low.

Using bounce flash: bounce flash still results in some shadowing but they tend to be softer and give a scene – or subject – a more three-dimensional appearance (courtesy Lastolite).

On the plus side, flashguns designed for bounce flash work do tend to be pretty powerful beasts so insufficient lighting will rarely be a problem.

Calculating the amount of flash light required is complex but again, and thankfully, it is done by the discrete computer in your camera. The camera will sense the amount of light entering the lens and turn off the flashlight (or 'quench' it) when sufficient is measured. Cunning, and remarkably accurate. Better still, the camera can also tell the flashgun the lens focal length (or what zoom focal length has been selected) so that it can adjust the spread of light accordingly.

Bounce with diffuser: using a reflector or diffuser with bounce flash can improve further on the bounce flash results (courtesy Lastolite).

This is all well and good, but what if you don't have a convenient surface from which to reflect the flash light? Don't worry. Many photographers pack, in their kitbag, small foldaway reflectors that can either be attached to the head of the flashgun or held – at an appropriate angle – over the top. Neither of these solutions will give quite the same general spread of lighting as bouncing from a ceiling but the results will be far superior to that of direct flash.

Slow sync

In the flash modes described so far, a very short exposure is used during which the flash is fired. In slow sync mode you combine a flash burst with a slow shutter speed. Normally used in low light and night conditions, this means that you will have your subject illuminated by the flash light but the long exposure will also allow other parts of the scene to be accurately exposed.

Imagine portraits shot in the late evening. The standard flash shot would effectively illuminate the subject but, as the shutter was open only a brief time, anything more would have been drastically underexposed and virtually invisible. Shoot the same scene with slow sync mode enabled and the flash would fire as before but because the shutter remains open, the surroundings would be better exposed.

This flash configuration is the basis of the scene mode called 'night mode' found on some cameras.

Front-curtain sync

Most SLR cameras have a shutter comprising a sliding pair of curtains. By varying the gap between these curtains and the speed the curtains pass across the sensor, we can control the amount of light getting through and the exposure. When you select front-curtain synchronization, the flash will fire

as soon as the first curtain has opened to reveal the sensor. That means the flash – whose duration may be as brief as 1/50,000 second – will freeze the motion at that point. If the exposure is longer, then any additional motion that is recorded appears as a slight trail or ghost image. Because this seems to be ahead of the subject, it is not the most natural result.

This is normally the mode that most SLR flashguns will default to unless you have configured them otherwise.

Rear-curtain sync

What happens if you synchronize the flash with the second curtain, firing it momentarily before this curtain closes? You record any motion, then with the final burst of flash,

Rear-curtain sync: this slow exposure was concluded with a rear-curtain synced burst of flash, freezing the dancers at the end of their motion.

freeze the action. This mode, rear-curtain sync, gives a more realistic look when used with moving subjects. You will get an effect of a ghostly trail again, but this time the trail will be behind the direction of motion. A much better sense of forward motion.

Stroboscopic mode

Whereas the modes we have discussed so far aim, progressively, to provide realistic lighting, the stroboscopic mode is very much a special effect lighting mode that can be used for creative, diagnostic or even comedic effects. In this mode (which is not offered by all flashguns) the flash will fire a series of identical flash bursts over a predetermined period. The idea is to freeze motion repeatedly during the exposure. You might use this mode, for example, if you wanted to capture a golfer's swing to analyse the motion.

This can be one of the more problematic modes to use: even a powerful flashgun will struggle to produce, say eight, flashes and so will tend to offer flashes at relatively low power. This will mean that you will probably have to shoot in near darkness to prevent getting too much contribution to the exposure (that may be as long as one second) from any ambient lighting sources.

Despite the hurdles, whether you choose to use it diagnostically or creatively, it is a great way of capturing motion effects.

Multiple flash

So far all the flash modes we have discussed have used a single flash either built into the camera or an attached flashgun. You need not, however, be restricted to a single flash. Many cameras now allow more than one flash to be

used. Of course, with multiple flash comes multiple expense as you'll need to invest in more than one flashgun but for stunning portraiture as well as creative photography, multiple flash can produce very powerful results.

Not so long ago to manage multiple flashes would require significant cabling and also access to a flashmeter. This specialized exposure meter would measure the amount of light emitted by the multiple flash sources and provide information for setting the camera.

Times have moved on now, however, and many cameras will be capable of monitoring the flash through the camera lens and adjust the flash output accordingly. You can even use wireless flashguns that don't need to be directly connected to the camera but are still controlled fully by it.

Multiple flash studio: the multiple flash system in this simple studio configuration is designed to illuminate subjects with minimal shadows.

In the simple studio setup shown above, the photographer has linked a simple compact digital camera to three basic studio flash units. Her aim was to shoot the subject – a silver antique clock – in a way that avoids hard shadows.

Single flash: using just one flash in the studio setup shown above produces harsh shadows.

Multiple flash: with the three flash units firing, the result is shadowless illumination. Good for some subjects (such as this) but not all.

Using and managing multi-flash configurations are well beyond the scope of this book but, if you have a yearning to have full control over the lighting environment of your subjects and want to compose and shoot stunning portraits, it's an avenue you should investigate further.

Unwanted flashes

The flash on some cameras, particularly compacts, is designed to turn on and fire automatically when the conditions dictate. This is good news for those that don't pay attention to the light levels – it will avoid underexposed shots – but can be bad news too. You may have intended to shoot a scene by the available light – flash may destroy the atmosphere and not deliver a shot as you intended. Worse still, the flash could fire when you are discreetly shooting a photo, perhaps at a place where flash photography is not permitted. Find out how to disable your flash as well as how to select different exposure modes.

Practice

Flash is not something to be afraid of. It is definitely a feature of your camera that can enhance your photographs and dramatically extend the photographic potential – something to embrace! Here are a few flash situations to start building your flash expertise:

* Direct flash: as the ambient light levels fall in early dusk, use direct flash to supplement the available light. If you do this as the light levels fall you'll see how the flash light (which is often constant) gradually becomes more prominent.

* Fill-in flash: shoot a subject (a person is best!) in bright sunlight without flash and with the fill-in flash mode selected. Compare the results: can you see how the modest amount of light from the fill-in flash improves the look of the subject, reducing shadows?

- If you have a flashgun that permits bounce flash, shoot the same interior scene (preferably with people – say a party or gathering) with direct flash and bounce flash. When you compare the shots, look at how much more natural the bounce flash result is and how the illumination is more even.

- Slow sync: have your long-suffering subject stand in front of an illuminated building and fire off a shot using direct flash and then slow sync. The former will probably render the building darkly but the slow sync will capture both the subject and the background effectively (remember to support the camera for a steady shot).

Summary

You'll have discovered in this chapter that far from being something that you relegate to night use, indoor use or avoid altogether, flash photography can be used in almost all photographic circumstances.

09

cameras and computers

In this chapter you will learn:

- what your computer can do with your digital photos
- how to transfer images to your computer
- about the options for downloading
- what to do with your downloaded images – and how to make sure you never lose any!

The reason that many people get into digital photography is because it's simple and fun. You can see the results instantaneously and share those results with those around you. In fact you can do much with your digital camera without ever going near a computer. However, throw one into the mix and your horizons – and options – expand enormously.

You and your computer

So what can you do when you, your camera and your computer make that crucial connection? How about these for starters:

* Store all your digital images – and any video clips you may have recorded – in one place
* Edit and manipulate selected images
* Create CDs and DVDs from your images and video
* Produce prints and other photo-based products
* Share your best photos by email or via a website.

Of course, you don't need to do all this straight off. To begin with it's useful to be able to use your computer to download images from your camera, file them away safely and take a good look at them. You've then freed your camera's memory cards to set about taking some great new photos.

It's also a good idea to make some copies of your image files early on so that, should anything catastrophic happen to your computer, or its hard disk, your important image collection can live again. It's these fundamental topics that we'll concentrate on in this chapter.

Downloading images from a camera

First things first. You'll need to get the images from your camera to the computer, saving them there in a way that makes them easy to retrieve. We'll make the presumption at this point that you've not yet installed – and perhaps not purchased – any image editing software. This is the software that you'll use later to manipulate, edit and ultimately print your photos. Many cameras, it should be pointed out, come with suitable software but for our immediate purposes we'll work with the basic tools that our computer operating system offers.

A word first about computers. This is a book about digital photography but we've made the presumption that you already have a computer so we're not going to labour on about the pros and cons of different computer models and

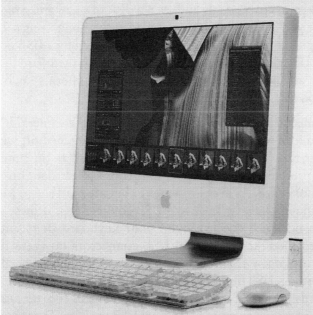

Computers for image manipulation: today even computers designed for general use (not just high-powered workstations) are more than capable of digital image work.

types. You'll have made your choice so let's explore the
capabilities. Remember, though, as we said at the top of
this chapter, many people get a great deal from digital
photography without going near a computer – we'll explore
some of these opportunities ourselves later.

Now to business. The process of downloading images to a
computer involves getting them from the camera's memory
card to the hard disk storage area of your computer. We
can do that in two different ways: using the camera directly
connected with the computer or an accessory card reader
in place of the camera.

Connecting a camera and computer

When you bought your digital camera you'll have been
supplied with a number of extras including a memory card,
camera strap, manuals and even a disk of software. Among
these you'll have also been provided with a connecting cable,
designed to connect your camera to a computer's USB port.
The USB ports, if you are not familiar with them, are those
that are normally used to connect peripherals such as
keyboard, mouse and printer.

Connect this cable to your computer and the camera. It's a
good idea to ensure that your camera is switched off when
doing this. There's a tiny risk that connecting to the camera
can produce a voltage spike that could affect data on the
memory card. As ever it's better to be safe than sorry. Most
computers have at least two USB connections. If these are
both occupied check around your keyboard or monitor.
Often there are additional USB connectors on these that
you can 'daisy chain' your camera to. If not, you'll need to
invest in a USB hub: these are rather like mains distribution
boards. Plug one into your computer's USB sockets and it
provides four or more additional USB sockets. That should
be sufficient for all your immediate needs.

Once you've effected a connection, turn on the camera. On some models you'll also have to manually switch the camera to review mode. In a few seconds your computer will recognize that the camera has been attached and will prompt you for action. It will normally ask if you want to download the images on the camera (for practical purposes your computer sees the camera as merely an external disc drive) to the computer.

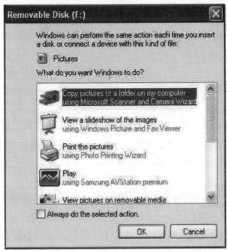

The download option in Windows XP: choose the Copy Pictures to a Folder option.

Say 'yes' (click OK) and the images will be copied. If you are doing so for the first time Windows will open the Scanner and Camera Wizard. This lets you select (or deselect) images to copy and then prompts you to give a name to the folder for these images. You can also choose a folder (normally defaulting to My Pictures) in which to put this.

Note that the images are copied to the computer, even though we talk about transferring or downloading; they remain on the memory card too until we choose to delete them.

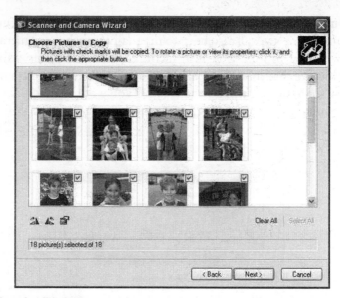

Downloading images: the Scanner and Camera Wizard lets you copy all – or just selected – images from the memory card (or camera) to a specified folder on your computer's hard disk.

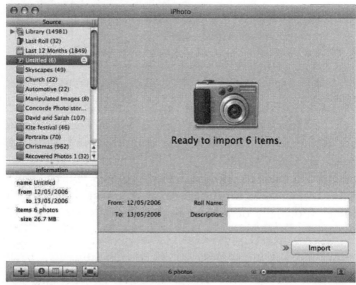

Downloading to a Macintosh: when a camera or memory card is detected by a Macintosh, the iPhoto download window will open.

If you are using a Macintosh computer connecting a camera will open the application iPhoto and then open the download screen. This will prompt you to download the images from the camera and advise you on the progress.

What happens if you don't get prompted to download images? Reliable though they are, computers occasionally get confused or have a software glitch that prevents them recognizing the camera and prompting you to download the images. Don't panic if this happens. Turning the camera off and on again can sometimes kick your system into operation. Otherwise you can manually transfer images.

On a Windows PC open My Computer and look for the camera. It may be marked as an E: drive or described as removable media. Open this drive and copy the files to a folder on your hard disk.

On a Macintosh the camera, or the memory card, will appear on the desktop. Double-click on it to open it and you can drag the image files within to a folder on your hard disk. You can even drag them onto iPhoto. This will copy them direct to the iPhoto library.

Connecting a card reader and computer

Many digital photographers don't like connecting their camera to the computer and prefer, instead, to use a card reader. A card reader saves wear and tear on the camera itself and avoids running down the camera's batteries unduly. You attach a card reader in exactly the same way as you would a camera and it provides a way of reading the memory card data directly. Simply take your memory card out of the camera and insert it into the appropriate slot on the card reader. The card will be recognized by your computer in exactly the same way as the camera and all we said with regard to the downloading via a camera applies equally here.

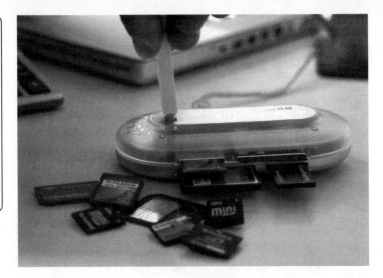

Card reader: connecting a card reader is simple. Most models, such as this, accept a range of different memory cards and so are ideal if you have more than one digital camera (or perhaps a memory card in your phone that you use for shooting images).

If you decide to invest in a card reader (which are not particularly expensive) check that you don't already have one. Why? Because many printers that offer photo quality printing have memory card readers, often hidden under dust flaps, and new PCs also often have card readers tucked behind covers. And, should you have decided you need a USB hub you can get a hub that also includes card readers. The only precaution you need take is that the cards your camera use are compatible with the slots in the card reader.

FireWire connections

Though less common than USB, some cameras (including a number of digital SLRs) and card readers can download using a FireWire cable. There was once a speed advantage in this when FireWire communications were much faster than the original USB. Now the faster USB2 connections are commonplace, USB2 has the slight speed advantage.

FireWire connector: FireWire is a fast connection system found on both Macintosh computers and some Windows PCs. The larger plugs are six-pin and the smaller, four. The two extra pins carry power for devices (such as some card readers and external disc drives) that need power.

No matter how you've made your connection, once the images have been downloaded you can disconnect your camera and card reader. If this is the first time you've downloaded images it's worth checking that they have been successfully transferred by checking in your My Pictures folder or in iPhoto (when using a Windows PC or Macintosh respectively) before you delete any images from your memory cards.

Safety first

Some downloading procedures (including that offered by iPhoto and some image editing applications) give you the option of deleting the images from the memory card after downloading. I tend never to take advantage of this option – just in case there's a problem in the download. If so (and it's yet to happen with me) you can then repeat the download. If your card is wiped you're stuck.

Also, take care when disconnecting. Whether you're using a PC or a Mac, FireWire or USB it's a good idea to eject the

camera or card from the computer rather than simply detach it. Doing so can sometimes result in the camera not being able to read the card subsequently (or at least until you fix the card by reconnecting it and ejecting it properly).

How do you eject a card or camera? On a PC find the device in My Computer, right-click and select Eject. Once it's disappeared you are safe to remove it. On a Macintosh, drag the icon of the camera or card to the waste bin (which will change to an Eject button) and drop it in.

After downloading

Now your images are safely transferred to your computer what next? There are two things you can do straightaway.

* Check your photos, discarding any poor quality ones
* Make sure that you have backup copies.

Even though you may well have discarded some obviously poor shots in camera, once loaded on your computer you've a chance to look at them in greater detail. It pays to be ruthless: we can shoot freely with our digital cameras which gives the opportunity to get several goes at each shot but there's little point in keeping each copy. Suss out the best and discard any that are inferior.

You can view your images as a slideshow in Windows – just click on the View as Slideshow option in the image folder's sidebar. In iPhoto you can select any image and move the slider at the base of the window to enlarge it.

Your image collection may be modest now – especially so if you've trimmed away the lesser quality images – but will soon grow significantly. As well as a major investment in time, this collection will comprise a great many memories for you and your family. It would be tragic to lose them. When we worked with film we could always seek out original negatives should our prints become damaged.

Digitally our photos exist only as data on a computer hard disk. If you've ever had a computer fail on you you'll already be sold on the benefit of keeping a reserve, backup copy of the valuable data on it. Now that your photo collection is resident, it becomes essential to back it up regularly too.

Backups can be done in different ways and with different levels of security:

1 Back up to a different part of a computer hard disk.
2 Back up to a separate hard disk.
3 Back up to an external hard disk.
4 Back up to a CD or DVD.

Option 1 protects us from any corruption of individual files – if an image file is damaged you've a backup copy elsewhere on your hard disk. If the disk itself fails, both copies could be lost.

Option 2 protects you from a failure of your computer's main hard disk but not if the computer fails. This option is only viable if your computer has two (or more) hard disks

Option 3 saves a copy of the data on an external hard disk. Should your computer fail you can restore the backup on the external hard disk to the repaired – or a new – computer.

Backing up to disk: external disks provide a safe way to back up large collections of images. Some offer a quick touch backup system.

Option 4 saves a copy (or copies) of your images files to removable disk such as a CD, DVD or, if your collection is really large and your computer supports it, Blu-ray.

Option 3 probably provides the most practical – you can set your computer to back up to an external disk on a regular basis while option 4 allows you to produce multiple backup copies cheaply.

My advice would be to use option 4 when your collection is small, backing up every time you add substantially to your image library. As the collection gets larger go for option 3. The investment in an external hard drive will be amply repaid in peace of mind if not in disaster recovery, should the worst happen.

In the real world, few of us are rigorous enough to back up all our important data on a sufficiently regular basis, which is why automated backup services are strongly recommended. This takes away the hassle of backing up and also compensates those of us with inferior memories.

Importing images from disk

Before we close it is worth taking a look at how we might import other images. In the early 1990s Kodak and other film manufacturers and processors produced PhotoCDs (once a specific file type, now a more generic description). More recently the option of having your film processed and the results written to a CD rather than (or as well as) being printed has been more widespread and given many aspiring digital photographers the opportunity to learn how to edit and manipulate images without investing in a digital camera.

You can import any images on disks like these and add them to your library of images from your digital camera. The method you use will depend on the type of disk (there

was never a true standard other than that of the original PhotoCD). In the worst case you will need to open the disk (double-click on it in My Computer or on the desktop) and drag the image files to a new folder. If you're lucky you may find that there's some basic software included on the disk that makes the process of saving to your computer's hard disk simpler.

Summary

Like using a digital camera, transferring your images to a computer is often a lot easier than you might imagine. Very quickly it will become a matter of routine and, as you will discover later on, when combined with appropriate library and viewing software, your growing photo library will become an important resource. That's why it's important that you build some form of backup process into your schedule. Take it from someone who has learned the hard way – you never appreciate the importance of backing up until your computer fails you and you lose something meaningful.

Hopefully you'll have some very meaningful digital photos very soon, so now we've got the technicalities out of the way, in the next chapter we'll take a look at how we can stop taking snaps and begin taking real photographs.

10

organizing and editing software

In this chapter you will learn:

- why it is important to keep your image collection well organized
- about cataloguing and editing software
- what to look for in good software

You've got your images successfully transferred to your computer. What next? There are two key things that you'll be using your computer for:

+ Managing and organizing you images
+ Editing and manipulating images.

To fulfil these tasks you'll need the corresponding software. Let's look at each of the tasks and the software that you might need.

Organizational software

In Chapter 9 we looked at the mechanics and practicalities of transferring your images to your computer. We noted that an initially modest collection of images, those downloaded from your first experiments with a digital camera, would be quickly dwarfed as your photo collection grew.

The problem comes if you've not been rigorous in the way you've stored your images. Your downloads could end up haphazardly scattered over your computer's hard disk, making it difficult – if not impossible – to subsequently locate specific images. And if you can't find them you can't use them – to produce prints, email to family or post on your forthcoming website.

The problem is that most people think that cataloguing images is a chore – a dull administrative task that diverts time and attention from shooting great photos. To a point that's right. But, like backing up important data on your computer, it's one of those tasks that you don't realize the importance of until too late. However, if you catalogue and organize your images from the start, the task is neither onerous nor diverting: in fact, it will make your subsequent adventures in digital imaging far more effective and efficient. Choose the right software, and the task will become easier still.

Preview	

Metadata / Keywords

Make	: Canon
Model	: Canon PowerShot S60
Date Time	: 2007-05-03T13:46:58+01:00
Date Time Original	: 2007-05-03T13:46:58+01:00
Date Time Digitized	: 2007-05-03T13:46:58+01:00
Exposure Time	: 1/1000 sec
Shutter Speed	: 1/1000 sec
F-Stop	: f/5.0
Aperture Value	: f/5.0
Max Aperture Value	: f/2.8
Focal Length	: 5.8 mm
Flash	: Did not fire, auto mode
Metering Mode	: Pattern
Pixel X Dimension	: 2592
Pixel Y Dimension	: 1944
Orientation	: Normal
X Resolution	: 180.0
Y Resolution	: 180.0
Resolution Unit	: Inches
Compressed Bits Per Pixel	: 5.0
EXIF Color Space	: sRGB
File Source	: DSC

Image data: when you shoot a digital image a wide range of relevant information is stored along with it. Use an application such as the image browser in Photoshop and you can see – and search – all this information.

The idea of organizational software is that it will firstly provide a single library for all your images – or at least keep firm track of your images, whether in a single directory or spread across your hard disk – and second it will allow you to uniquely identify every image.

Data and keywords

You won't have realized it, but every time you shoot an image it isn't just the photo itself that's recorded on the memory card. Along with each and every image a raft of data is also recorded. This includes the camera used, the camera settings, date, time, whether the flash was used – in fact everything that relates to the configuration of the camera. This data will come in really useful when we come to catalogue all our images. It provides a unique and useful identity for each shot.

When you come to catalogue your images you'll also apply some additional terms to each image, ones that relate to what you've been shooting.

For example, a photographer takes a photograph of his daughter, Sarah at Tower Bridge in London when on a holiday there in 2008. The keywords the photographer might assign are: Sarah, daughter, London, holiday, Tower Bridge and 2008.

Now, in a few weeks (or months or even years) when he wants to collect together all the photographs of his daughter he could search the collection using the keyword 'Sarah'. He could also search using 'daughter' and, if he had more than one daughter, all the relevant images would be retrieved. If he entered 'Sarah' and 'holiday', only the shots of his daughter taken when on holiday would be located. The search could be refined further by including some of the automatically collected data, such as the camera used. These, manually added data items are called keywords.

Applications for cataloguing and organizing

The good news is that some of the most popular image editing applications, including Photoshop Elements and iPhoto, both of which we will look at shortly, have organizational software modules. Also, many digital cameras come with a collection of software applications bundled on CD. Often these include a complimentary copy of cataloguing and editing applications. These may not be the latest or greatest versions but if they are free, what the heck?

If you're not so fortunate, check out applications such as Adobe's Photoshop Album. This is a particularly easy-to-use cataloguing application. When you download images they are automatically catalogued according to the date upon which they were shot. Then, you can take a look at the software's calendar view and see small thumbnails of images corresponding to the dates on the calendar. You can then go on to add your keywords to make your subsequent searching more effective.

Photoshop Album: this modest application from the Adobe Photoshop stable is very effective for organizing images and, even if you can only remember the approximate date when you shot them, makes location simple.

There are many more applications that offer organizing and cataloguing options. Many enthusiast photographers, for example, use a product called Portfolio from Extensis Software. This is a much more rigorous application but still easy to use, particularly if you catalogue your images regularly. Portfolio's advantage is that it can handle large and complex collections of images (that may be scattered over multiple computer disks and drives) as easily as a more modest collection.

Photo editing software

The photographs you shoot with your digital camera could be loaded onto your computer and then printed, with no further intervention on your part. In a sense that would make the computer pretty much redundant as anything other than an image storage device: all it would be doing is providing the connectivity between your image files and printer.

However, the images delivered to the computer by your camera may not be showing at their best. Good though they are, digital cameras can sometimes need a little help to give photos the best exposure, colour or contrast. Adjustments to all these – and more – are possible by using photo editing software.

Better still, the image modifications are not limited to these general corrective measures. You can exploit the power of digital technology to enhance and modify images. Elements from separate images can easily be combined to create stronger images, twist reality or even deceive. Damaging elements – those that detract from the quality of the image – can be removed or changed.

Before digital photography, if you found damage or blemishes on an image (whether part of the original image or due to the printing process) corrections involved

retouching: using inks and paints to conceal the relevant areas. If the image needed more complex modification that would require intense (and highly skilled) darkroom work.

Now, with some reasonably priced photo editing software and just a modest amount of skill, manipulations beyond the scope of conventional photographers become simple.

So what should we look for in photo editing applications? Not so long ago that question would require a long and detailed response. Today both the software market and the hardware – namely our computer – have become more mature. There is a wide range of applications available and it's fair to say that they each offer the essential features for improving and modifying your photographs. Where they tend to differ is in the degree of sophistication and, corresponding with this, price.

Traditionally, photo editing software has been conveniently divided into three categories that we can describe as 'simple', 'intermediate' and 'professional'. Today, as the applications have evolved we can divide them into two categories, 'simple' and 'advanced'. Let us take a look at the characteristics of each.

Simple applications

This is something of a misnomer, as these applications today tend to offer a wide range of sophisticated features. The 'simple' prefix essentially defines how easy they are to use. These applications are designed for the general photographer who wants to quickly and efficiently improve photographs downloaded from the camera. Software in this category will have much of the functionality you might expect in a higher-level product but will also feature a wide range of quick-fix controls that will, with the minimum of keystrokes or mouse moves, enhance your photos.

The beauty of simple applications is that you can quickly enhance your photos when time is of the essence but when you have more time, and as your skills increase, there are additional features to explore and use.

What applications fall into this category? There are many, but the more popular to check out are:

• Adobe Photoshop Elements (Windows and Macintosh)
• iPhoto (Macintosh)
• Corel Paint Shop Pro.

A good way to check out applications prior to committing your cash to them is to download a free trial. These offer you the chance to use the software for free (normally for 30 days) so that you can assess if it's going to meet your needs. If not, the trial will expire but if you like what you've been playing with you can pay your fee and upgrade to the unrestricted version.

Keep an eye open for old versions of software applications. Software is continually being improved and enhanced with

iPhoto: this organizing and editing application comes free on all Macintosh computers and is also part of the iLife program suite.

Photoshop Elements: based on the professional application Photoshop, this version includes most of the important features along with some helpful routines for the enthusiast and beginner.

Paint Shop Pro: this popular application is designed for both beginners and the keener photographer.

new editions released approximately every year to 18 months. The superseded versions may be given a wide berth by the keen enthusiast who wants the latest and greatest, but they are still going to be well specified and if offered at an attractive price, may be worth considering.

Advanced applications

When it comes to advanced applications the market is dominated by Adobe's Photoshop. The application that spawned the junior sibling Photoshop Elements, this is almost the only application that enthusiasts and professionals use. This program is so well specified that few photographers have explored every tool and feature it has to offer.

Thanks to an interface that has been honed and refined over the years, Photoshop is remarkably easy to use even by those with a limited knowledge of image editing. Tools

Photoshop CS3: the professional's choice, Photoshop, is slick to use and comprehensive. Sadly, the price reflects this.

fall easily to hand and performing manipulations, to an entire image or more locally, is equally simple. However, because this is designed to meet the needs of the enthusiast and professional it may not be the application to try if you are totally new to photo editing. Unlike the simpler applications, there are fewer shortcuts and less in the way of tutorials and help. If that doesn't dissuade you, then the price might – compared with simple applications you would be looking at a price up to ten times that of a more basic application.

Computers and software

Photo manipulation software is powerful stuff and pretty demanding on computing power. Once, not so long ago, your choice of software application was very firmly determined by the computer you had: some computers just didn't have the raw computing power to handle some of the more demanding applications. Others would run the software but be restricted in using some of the more advanced (and computer power hungry) features.

Today we are fortunate in that virtually all computers will run any of the applications available on the market. It still makes sense to check out (via the software's box or the manufacturer's website) what the recommended computer specifications are. It is the recommended specifications – rather than the minimum spec (which is usually just sufficient for running the software) – that will determine the minimum needed to successfully use the software.

Laptop or desktop? Again it doesn't matter. Many laptops today offer power and features that would shame some desktop machines. The only caveat that I would introduce is screen size. You'll enjoy your photo editing more if you can use a large screen. Not only will you be able to see more of your images at a large scale, but also you'll have

enough screen space for the convenient display of all the various palettes used by the software. Laptops – even the larger ones that have seventeen-inch displays – can appear a bit meagre. Sooner or later, many people bitten by the photo editing bug opt for a large screen. Today, flat screens of 20 inches or more are reasonably affordable and can add much to your photo editing. Worth checking out – and they'll connect to your laptop or desktop.

Displays: the bigger the better. Large screens are more effective for detailed image editing and working for longer sessions.

Summary

Armed with a camera, computer and photo organizing and editing software, you have the means to transform the raw photos into powerful images. Acquiring the software needn't be expensive. Sometimes you'll find your camera comes complete with all the software you'll need. You can even find some simple applications that can be downloaded for free from the Internet. But, to be honest, a good quality application capable of meeting all your immediate – and mid-term needs – will not be expensive and will provide you with the means of producing those masterpiece images. In the next chapters we'll see how.

simple image editing

In this chapter you will learn:

- how to use 'quick-fix' tools to improve images instantly
- about making photos sharper
- how to improve the colour and brightness of images
- about some special effects

There are essentially two ways we can go about correcting or improving our photographs. We can apply our image editor's tools to the whole of an image at once or we can be selective, applying the tools to smaller areas. In the former category we can consider adjusting the brightness and contrast. The latter would include what we might call corrective surgery: removing a distracting road sign (or blemish from a portrait subject's face) or selectively modifying colour.

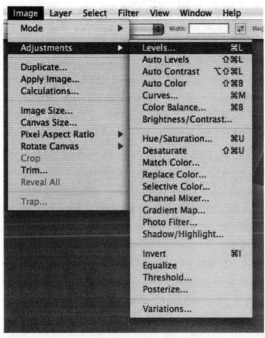

Adjustments menu: this menu (here in Photoshop) is the access point to many of the whole-image as well as some more selective corrections.

In this chapter we'll look at overall corrections. We'll start here because these are easy to apply and are perfect for giving okay photographs something of a boost. They are also relatively easy to apply (compared with the selective tools that need a little more expertise) so are a good place to start if you have had no previous experience.

Quick fixes

Digital cameras are adept at producing good images at the press of a button. If you were to print them, you would probably be quite satisfied with the result. However, the images we receive directly from the camera often don't give entirely of their best. That's why most image editing applications offer quick adjustment buttons.

In Photoshop Elements, as a good case in point, there's a feature called Quick Fix, and within this there's Smart Fix. Select this and the lighting, colour and contrast in your image will be fixed instantly. You'll notice that – for the majority of your images – this will greatly enhance them. Colours will brighten, without getting garish, contrast will be improved to deliver true blacks and whites where there may have just been dark greys and light greys, and the overall 'look' of the picture will be better.

I say 'the majority of images' because Smart Fix, like all quick fix tools tends to be something of a dumb beast. It delivers the improvements by adjusting the parameters (colour, contrast and so on) according to a formula, and this is determined by reference to an 'average' image. So long as your image conforms broadly to this average, the adjustments will enhance the image. If it is not an average one, then quick fixes can actually harm your image. You'll see this if you shoot some sunset photographs. Apply a quick fix and you could find all those powerful reds and yellows diminished as your software adjusts the balance of colours towards an average value. Think of quick-fix tools as making a best guess. Sometimes they guess correctly, sometimes not.

Because some images are adversely affected like this you'll find that as well as instant fix buttons (like Smart Fix) there are also more selective corrections that will instantly adjust only the brightness levels, or only the contrast or only the colour balance.

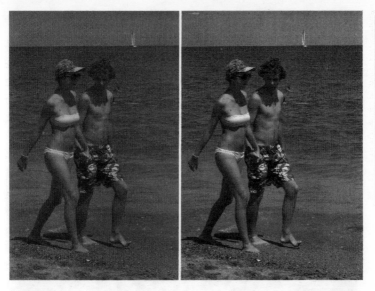

Quick fix: even with black and white, the quick fix tool brings clear improvements – the contrast is enhanced and the photo is much brighter.

Now, if you apply the auto contrast command to your sunset you'll find the contrast range enhanced yet the colour will remain unchanged. Remember, with all commands there's an undo button: if you apply a command, a tool or an effect and the results are damaging to your image you can step back. You can, therefore, apply effects and observe the results with the knowledge that you've done nothing permanent. Only when you save your image are your changes applied.

You'll find that there are actually quite a number of quick-fix or auto-fixing buttons throughout most image editing applications. As with the tools we've described above they make a best guess but I would say don't knock them. If they work – use them; if they don't then choose another method!

Red-eye removal

A good example of another quick fix is the Red-eye Removal tool. In Chapter 8 we took a look at the causes of red eye and also some on-the-spot ways of avoiding it. Often these are not totally effective so for these images – and those where the effect is more severe – there's a special corrective tool.

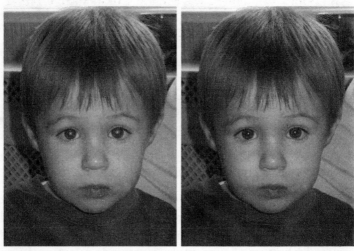

Red eye: it's easy to fall victim of this problem but with digital tools, pretty easy to fix it.

Using it is simple. Drag the cursor over the affected eyes, release the mouse button and it's sorted. Simple, but very effective. How does it work? When you define the area to be corrected, the software identifies those parts of the scene that are red and replaces the colour with a convincing and more natural black. Again, this is a dumb tool. If you were slapdash about the area of the image you selected for correction – perhaps including a subject's red dress, or a red object in the background, these areas too will be rendered black.

Making photographs sharper

Sharp, well-focused images are what we strive for. Often, though your photographs may be sharp, they may not be critically so, and this can make quite a difference to them.

Fortunately, you can attend to the sharpness of your image using sharpness filters. It's worth making a brief digression at this point. You'll find a large number of filters in imaging applications. Some of these are similar to the filters that you might attach to your camera but the majority are quite different. They have the same purpose – to modify images – and like conventional filters some are useful, some less so.

The sharpen filters are a group of filters that apply varying amounts of sharpness to an image. The three that we might use are Sharpen, Sharpen More and Unsharp Mask.

Sharpen applies a modest amount of sharpening. It's perfect if you just want to sharpen a slightly soft image.

Sharpen More is somewhat stronger in its effect (around four times that of Sharpen) and should be used more sparingly – it can result in oversharpening.

Sharpen More: oversharpen your images and you'll find that they look flat and that artefacts (bright lines and halos) begin to affect the image.

Unsharp Mask is a more complex tool, which needs a bit of practice to exploit. You can use the controls of this tool to refine the amount of sharpness to match the subject, and also apply the effect more selectively. Sharpen and Sharpen More attempt to sharpen every part of the image – so will even produce sharpening effects in a blue sky if it detects variations in colour. This is the downside of these filters. The Unsharp Mask filter lets us limit the effect to higher contrast areas. How do you get the best from this filter? Experiment with it. Move the slider controls and watch the effect on the image.

How do the sharpening filters work? All they do is enhance contrast. The software detects high contrast areas in a photo (which normally define edges and boundaries) and increases the contrast. The result is an apparent increase in the sharpness at those boundaries. The mistake many people make when they become aware of the sharpening filters is that they believe them to be an excuse for bad practice. Why bother getting your photographs absolutely sharp in

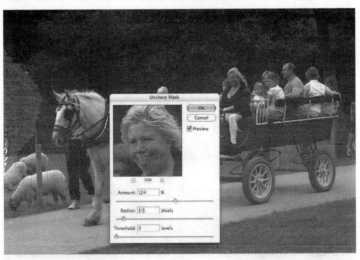

The Unsharp Mask filter: used carefully you can make a soft image credibly sharp with this filter.

the first place when you can attend to this later? Because, although these filters add sharpness they don't correct poor focus. If you shoot a photo that is not properly (and precisely) focused, small fine details that should be in the image are not recorded. No amount of sharpening can compensate for this.

So how should you best use the sharpen filters? Use them to improve the sharpness only when necessary. Use the minimum amount of sharpening. Should you need to use Sharpen More, chances are your photo is not sufficiently sharp in the first place.

Making photographs brighter and more colourful

If you find that quick-fix tools are too brusque in their application you need to take a look at the equivalent manual versions of the same corrective tools. These include Brightness/Contrast, for (at the risk of stating the obvious) adjusting the brightness and contrast; Hue/Saturation, the amount of colour in the scene and the corresponding hue; and Levels – the distribution of tonal levels in your images.

Brightness/Contrast: This command is simple and obvious. Select it and you can adjust the brightness and contrast in your image across a wide range of potential settings. In general, digital images tend to be a little flat so far as contrast is concerned so you'll probably find yourself nudging the contrast slider up (that is, normally to the right) a touch. Doing so can sometimes affect the brightness of the image so you may find that you need to alter the brightness slider accordingly.

Hue/Saturation: Saturation describes the amount of colour in an image. At zero saturation the image will be black and white, at 100% everything will be luridly coloured. You can adjust the slider by more modest amounts to pep up

those holiday photos to give bluer skies and sea, and enhanced skin tones. Be gentle. Adjust the slider only a small amount or colours risk becoming unnatural.

You can also use the pull-down menu in the dialogue box for this tool, to select specific colours. This can be important if you want, say, to increase the saturation in the sky but not the green foliage in the landscape: select blue or cyan and increase the saturation only for these colours.

When you have selected a specific colour you can also use the hue slider to alter the colour. Often the results of changing the hue can be bizarre and unrealistic but sometimes not. I often find that the skies in digital images can be too cyan in colour. Now, select cyan from the drop-down menu and move the hue slider a modest amount (say 5%) to the right and you'll change the sky to a wonderful azure blue.

Levels

Unlike the previous tools with their simple sliders, your first look at the Levels dialogue box can be a little daunting. It features a prominent graph and an array of sliders and buttons. In fact, it is comparatively simple to interpret. The graph illustrates how the data in your image is distributed between the darkest tones (to the left of the graph) and the lightest (to the right). In a good digital image you'll have a graph with data at all points, and a graph that rises towards the centre. Should you have any flat spots – where there is no data – it implies there are no corresponding tones in the image.

This becomes significant if there is little or no data at the extreme ends of the graph. This suggests that your image does not have true blacks (data missing from the left) or bright whites (data missing from the right). Your image will be lacking in contrast and not have the 'punch' or impact it might.

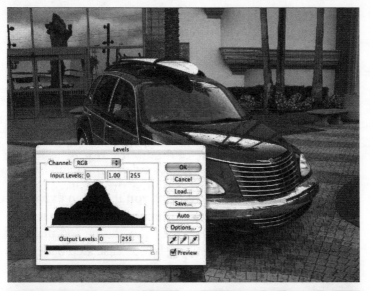

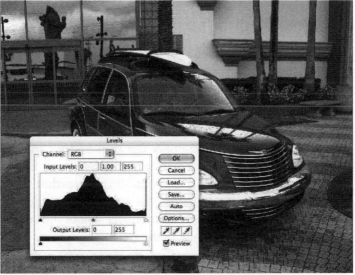

Levels: for a good image you need a good distribution of levels. In the first illustration it's clear that there are areas at the extremes of the levels graph with no data. This corresponds to blacks and whites. Adjust the sliders and you can expand the graph to ensure that the darkest parts of the scene are represented as black and the lightest, white.

We can correct this very easily. Below the graph you'll see three triangular markers that are actually sliders. The one to the left represents the black point. Move this to the point on the graph (normally where the data begins) that you want represented in your image as black. To the right is the white point which needs to be moved to the point (normally at the end) that you want represented as white. The middle slider is for adjusting the mid-tones. There's no precise place for this but, as a good rule of thumb (or at least as a start point) put it near the central peak of the graph.

When you apply these corrections you'll find an expanded tonal range in your image and much better contrast. You can overdo the correction, perhaps rendering too many of the dark tones darker, or black. In this case step backward and repeat but move the slider a little less.

Shadow/Highlight

This is a neat little tool that is a comparatively recent addition to our toolset. It's designed to handle extreme shadow and highlight areas in a scene. Shadows will be brightened (and the amount of brightening is proportional to how dark they are) and, similarly, highlights dimmed.

When you first select and apply the tool it does so with preset values that will immediately brighten up your image. On closer inspection you'll probably realize that these adjustments are too severe so you can use the sliders to reduce the impact. This tool works best where the image, overall, is well exposed but there are large shadow areas that prove distracting.

When less is more

Don't feel that, because these tools are available to you, you have to use them every time. Many images will be fine,

Shadow/Highlight: where your image may be compromised by too many shadow areas the Shadow/Highlight command is a great way of brightening these while maintaining the relative tonal range.

straight from the camera. Others might just need a modest application of a selected tool. It is easy, particularly when you are new to image editing, to be too heavy-handed. Do so and your photographs will look obviously manipulated. The aim when applying any correction is to improve your images, but in a way that never becomes obvious.

Some fun effects

Despite my protestations about keeping your manipulations subtle, some effects and techniques are very obvious indeed. Some photographers can be very precious about their work and about photography. They will scoff at many of the features in image editing applications because they are, not to put too fine a point on it, utterly frivolous. But that's not to say that you can't have a bit of fun using them. In fact, you can create some powerful images if you use a few selected special effects – just don't use them too often.

Here are a few of my favourites and, just in case you should need it, a little justification for using them.

Posterize

Cameras today can offer finely detailed images that can survive – in some cases – massive enlargement. Better still, the sensors are adept at showing detailed gradations in

Posterize: applying the posterize effect turns images into bold graphics. The technique is best applied to simple images – and the effect varies significantly if you change the number of levels in the dialogue box.

colour, brightness and tone. Sometimes, though, you may want to produce a bold graphic look. That's what the posterize command offers. It will reduce your image to areas of even colour determined by the number of (colour) levels that you enter. It gives the boldest of effects if you enter 3, 4, or 5 levels; enter higher numbers and you'll lose the impact.

Artistic filters

Want to change your photograph into a work of art? The Artistic Filter set is for you! Amongst the wide range of filters on offer are those that will transform your photo to a painted image, watercolour, oil painting and so on. Not all filters will work successfully with all images so it is always a good idea to test the effect first. Some of the filters also have slider controls that allow you to vary the amount of effect, the length of brush strokes and so on. You can even combine some brush effects with a canvas look, to give the appearance of a painting on canvas.

Artistic filters: these give your images that painted look. Great if you want to print your image onto canvas.

Noise and grain

We have become so conditioned by the shortcomings of conventional film that we now expect some subjects to make use of those shortcomings – for example with gritty, earthy subjects we expect these shots to make use of film grain. The CCD sensors in our cameras do produce noise artefacts (e.g. the halo effect around objects) but these are rarely as potent, so there's a whole group of filters dedicated to add grain-like noise of various kinds to our images. Used with hard landscapes, industrial scenes or certain portraits they can be very effective.

Grain: introducing grain is a great way to add grittiness to an image.

Practice

In the next chapter we will take a closer look at some of the other tools that will let us refine selected parts of the image, but in the meantime why not try out some of the tools we've explored here and examine the results.

♦ Get to know the quick-fix tools. Choose a selection of images and apply the Auto Levels or Auto Fix command. Take a look at the result. Is it an improvement?

♦ Try the same with a photo that's predominantly one colour – a seascape or a vivid sunset. After applying the quick-fix tool is the result better, worse, or weird? These tools don't do a good job in all circumstances!

♦ Remove red eye. No matter how careful you are, you'll have a few shots with the subjects afflicted by red-eye. Use the red-eye tool to correct it. Was it successful? It won't always be – you may have to resort to using a brush tool to paint over missed or poorly corrected areas.

♦ Sharpen images. If you have some photos that look a little soft, try out the sharpening tools. When you apply them, zoom in on a small part of the image and note the difference the sharpening makes. Get in close (particularly with Sharpen More) and you'll begin to see some digital artefacts appearing).

♦ Get familiar with the Unsharp Mask. This tool takes some practice, but have a play. Set a varying amount and notice the different effects on the image. Increase the radius and try again. Note also how, if you set a threshold (say 10), the sharpening effect is not applied to areas of continuous tone, such as the sky, or skin.

♦ Have fun with the artistic filters. Apply these – in various strengths – and watch the results. Some will lead to great artworks others ... well, not all image manipulations are good. Get a feel for those that work well and those that will enhance your images.

Summary

In this chapter we've taken our first steps in image manipulation. Perhaps in the eyes of technically adept image manipulators and pro photographers we've been somewhat blasé: applying simple auto fix tools and other commands that are not necessarily the most subtle. However, our aim is to turn good photos into great ones and by using these tools this is indeed possible with the least amount of effort on our part. Of course you could spend a great deal longer working on each image and get even better results. But living in the real world you will probably want to get great results fast. That's what these tools deliver.

12

more image editing tools

In this chapter you will learn:

- how to make selections
- how to adjust colour, including variations
- about the clone and rubber stamp tools
- how to repair and fix photos

Often you need to perform more localized edits on your images. For example, you may want to change the colour of an object, to make it more vibrant. You may want to remove an item – a spot or blemish on a portrait subject – or even combine parts of one image with another. All these – and more – are possible when we get to grips with some more of the tools that image editing applications offer.

To make a change to a specific area of the image requires that you are able to select it. So, before we get down to details of how to make changes let's take a look at how we can select the areas you want to change.

Selections based on colour

Think about how you might want to identify objects in your scene. You might do so on the basis of the colour. For example, a prominent red car that dominates a photo and distracts your eyes from the true subject.

The main tool designed for making selections based on and object's colour is called the Magic Wand. If you select this and click on an area of colour, all the adjacent pixels of the same colour will be selected.

This tool comes with two main controls. One, Contiguous, is a simple one. Select this and only pixels that are

Magic wand: the key feature for making selections according to colour.

contiguous with (that is, joined to) any you click on will become selected. Other areas in the scene of the same colour will not be selected. Deselect this button and pixels of the same colour throughout the image will be added to the selection.

The second control is called Tolerance. You can enter a figure here to determine how wide a range of similar colours are included in your selection. If you set a low figure here only those pixels of a colour very similar to that selected will be added. With a higher figure a wider range of tones will be selected. Getting the right value can be a bit problematic – setting too low a figure can leave you with non-selected pixels on your subject while too high a figure can result in pixels all across the image being selected. Even if you have an area that looks to be of very similar colour – a blue sky for example – that colour can change significantly across the scene and there will be localized pixels of a quite different colour. The default setting (normally 32, referring to a range of 16 tones above and below that of the selected one) is normally a good starting point.

Where might you use this selection tool? The most common use is to select the sky in a scene. If you want to select a bland overcast or clear blue sky so that you can paste in something more interesting (from another image for example) you can select it all at once with the Magic Wand.

Drawbacks to the Magic Wand? One modest weakness: because of the need to get the tolerance setting just right you can sometimes end up with a selection in which discrete pixels are not selected. This only becomes obvious when you come to perform your modification on the selection. You can cure it by using the Zoom tool to look closely at the selection and, if necessary, add these orphaned pixels to the selection (see below for details about adding to an existing selection).

Selections based on shape

Not all objects are of a homogeneous colour so you may find it easier to use the shape. For this you'll need to use another selection tool, the Lasso. This comes in various guises: a standard lasso that you use to draw around the perimeter of your object freehand, the magnetic lasso, which cleverly determines the edge of your selected object and accurately follows the selection edge, and finally, the polygonal lasso. The latter lets you define the edge of the selection using a series of straight lines – useful for subjects with straight sides.

The Lasso tool: the Lasso has three variants, freehand, magnetic and polygonal, selected by clicking on the tool in the toolbar.

The freehand lasso is great for making an impromptu selection but does require a smooth, steady hand. That's why, in the majority of cases you'll get better results using the magnetic lasso. Start your selection at a convenient point on the subject's edge and as you draw around the edge, the selection line will automatically attach itself. It's not foolproof: the magnetic lasso relies on detecting the high contrast between pixels that you get at an edge. Sometimes, if there are multiple routes that the lasso could follow, it may need a helping hand – you can click along the intended route, and the lasso will follow that.

The main control you have with this tool (and you'll find it offered by some other selection tools too) is the Feather Radius. This determines how soft the edge of your selection will be. Set it to zero and you'll have a very hard edge to

the selection. Set it to a modest number, say 10 or 20 and you'll get a softer edge. Set higher numbers still and you'll get a correspondingly softer edge.

Typically, rather than setting zero, you would set a Feather Radius of one or two: this will help blend any effects you apply to the selection with the adjacent pixels.

Selections based on fixed shapes

You can also select part of your images using the marquee tools. These select rectangular or oval areas and any selection is independent of what is within the image. You might use these if you wanted, for example, to add a frame

A vignette is a good way to present a portrait or aged scene. Choose a colour for the vignette that complements, rather than jars with, the subject.

to an image or, with the oval marquee, a vignette, as shown above. This was achieved by dragging the marquee across the image and then selecting (using the selection controls) Invert Selection. Now the area outside the marquee is active and you could paint over this area using the brush tool.

Modifying selections

Sadly, not all the objects in our images that we want to select will conform to our rules on colour and shape. Many may prove slightly difficult to select. Fortunately you don't have to restrict yourself to a single selection technique. You could, for example, begin your selection by using the Magic Wand, then add to that selection using the Lasso. You have to ensure, if you are adding to a selection, that you enable the correct mode, for example, using the selection buttons.

Selection buttons in Photoshop.

Make a selection Find intersection of two selections
 Add to a selection Remove element from the selection

You can also subtract from a selection. Consider the case of selecting a person with hands on hips. You might use the Lasso tool to select the outline of the person. Though this excludes the background around the subject it would include the background visible between the subject's arm and body. You can use the Subtract from Selection button to select and remove these parts of the original selection.

The Select menu

The Select menu allows the modification of a selection. You can, for example, grow or contract a selection by a specified number of pixels. You can change the feathering amount or select a specified colour range.

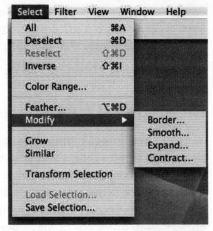

Selection menu: this is from Photoshop but those in other applications have similar features.

The options at the top of the menu let you select All (to select the entire image, perhaps to copy to another), Deselect (to remove all selections in a scene), Reselect (undo the deselection) and Invert (swap selected and non-selected parts of the scene).

Now you've made a successful selection, what next? Once you've isolated your subject you can:

• Change the brightness, colour or contrast of the selection.

• Copy the selection and paste it somewhere else within the current image or into another one.

• Sharpen the selected area to make it more prominent.

• Invert the selection (so everything but the original selection is selected) and blur – again to increase the emphasis of the subject.

• Apply a special effect to the selection or the surroundings (for example, removing the colour from the background).

• Changing the scale of the subject, perhaps to enlarge it.

In fact, you can play around to your heart's content. Some modifications will add to the realism and impact of the original image, others will be more fanciful. But no one said photography couldn't be fun too!

Another use for selections (although you don't necessarily need to use it with a selection) is to change the contents of the selection entirely. For this we can use the Clone/Rubber Stamp tool.

Cloning and rubber stamping

When digital image manipulation was in its infancy one of the key attributes that it was sold to photographers on was the ability to remove damaging parts of a scene, or add new elements. Now, proponents advised, if you found that the subject of your shots had the proverbial telegraph pole appearing to grow out of his or her head, you could remove it. Or you could add someone (or something) from one photo to another. A missing guest could be added to a wedding group for example.

The tool we use to perform these apparently magical corrections is called the Rubber Stamp or, by virtue of the fact it produces identical copies of areas of pixels elsewhere in the image, the Clone tool. Whatever name you prefer it's easiest to think of it as a copy and paste tool. It copies pixels from one area and pastes them in another.

You can use it to get rid of dust spots and scratches on your images, blemishes on the faces of portrait subjects and other unsightly marks. At a more advanced level you can use it to conceal distracting elements (such as that telegraph pole) or (by cloning from a second image) paste in that extra person in the group photo.

Using the Clone tool is simplicity itself. You begin by defining a point where you want to begin copying pixels from. You then move your cursor to the point where you want to paste those pixels. Now, as you move the cursor in a painting motion, the point you are cloning from will move in parallel allowing you to convincingly conceal or copy part of the scene.

You can select any brush to paint your cloned pixels with – small or large, hard or soft, any that will give a natural look to the finished image.

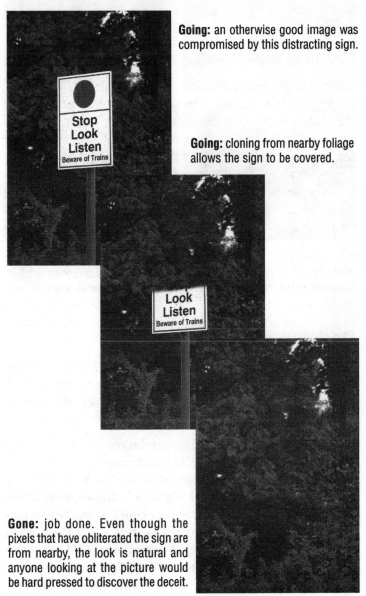

Going: an otherwise good image was compromised by this distracting sign.

Going: cloning from nearby foliage allows the sign to be covered.

Gone: job done. Even though the pixels that have obliterated the sign are from nearby, the look is natural and anyone looking at the picture would be hard pressed to discover the deceit.

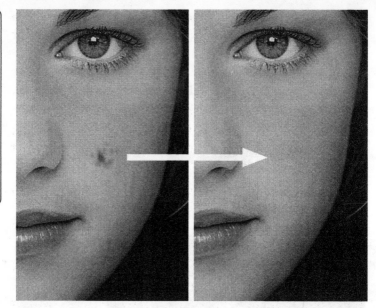

Blemish removal: a quick dab with the Clone tool will remove spots and blemishes. Make your selection from pixels close to the area to be patched, to avoid the repair becoming apparent through a change in colour or tone.

Dodging and burning

Here are a couple of tools that successfully made the transition from conventional photography to digital. The only difference is that in the digital darkroom – your computer – they are infinitely easier to use.

Back in the days of the traditional darkroom, dodging and burning involved carefully altering the amount of light that fell on specific areas of a print when you were printing negatives in the enlarger. Using small tools or wands, the photographer could reduce the exposure from the enlarger to some parts of the scene. The result was that those areas would appear lighter in the final print than would otherwise be the case. This was known as dodging. The converse – burning – would use sheets of card with holes cut in. With

these, parts of the scene could be given longer exposures to the enlarger lamp and so, when processed, would appear darker.

Dodging and burning would be used to change the contrast of the image on a localized basis, enhancing the contrast in images that would otherwise be considered 'flat' from a contrast point of view or reducing the contrast where that was originally too high and perhaps beyond the range that could be successfully printed.

The digital equivalents allow us to use brushes to brush over selected parts of the image to dodge and burn them. Unlike our forebears we can work on real positive images and can see the effect of the applications in real time.

When you use either of these tools you can apply the effect selectively to either the highlights in the image, the mid-tones or the shadow areas. With this level of control it becomes easy to extend or reduce the contrast in the scene.

Dodge and Burn: the Dodge and Burn tools are ideal for emphasizing texture and detail which previously was not immediately visible. Here the Burn tool has been used to bring out the detail in this cloudscape.

You can also vary the exposure. Think of this as the light from the old darkroom enlarger. The greater the exposure, the stronger the effect will be. Normally you would use very small amounts of exposure – perhaps 5% or maybe less – and build up the results slowly.

There's no doubt that, unlike virtually all the tools and features we've discussed so far, this one needs a little practice to get right. It helps – though it is by no means essential as I can attest – to have an artistic eye to ensure that you get balanced results throughout the image.

Practice

Avoid overload by starting with simple corrections and develop your awareness and skill progressively. Try these examples to start developing that skill:

* Select the sky. Choose one of your images with a bright blue sky. Use the Magic Wand tool to select this sky with the tolerance set to 32. Was it successful? Try increasing the tolerance but keep an eye on the rest of the scene. Often when you increase the tolerance other parts of the scene may be selected if the Contiguous button is not selected.

* Select a coloured object. Choose a coloured object in a scene. Use the Magic Wand to select again. You will probably not be able to select it accurately with a single use of the Magic Wand; use the Add to Selection button to gradually build up the selection.

* Change the colour of your selected object. Select the Hue/Saturation control and move the Hue slider. Can you see how the colour of the selection is modified?

* Use the Clone/Rubber Stamp tool. Use the tool to remove an object in one of your photos. A road sign in a street scene, a satellite dish on a cottage or even a person walking in the background make good candidates. Be

sure to select a soft-edged brush to make the cloned pixels blend in well with the existing ones in the area.

♦ Dodge and Burn. Find an image with a cloudy sky. Use the Dodge and Burn tools to emphasize the clouds; burn (darken) the bottom parts of the clouds and dodge the brighter parts to increase the contrast. Make sure you select a low exposure setting (5 to 10%) to avoid too dramatic a change.

As you might imagine, or have seen for yourself, there is a great deal more to image editing applications than we have seen in these two chapters. Don't feel afraid of exploring what they have to offer. You don't commit anything to your image until you save it. Apply effects, use the tools and practise the techniques in the certain knowledge that if you don't like the results, you've not affected precious images. And if you are pleased with the results, save. Better still, save the image under a different filename – then you'll preserve your original image along with your new creation.

Summary

Image manipulation applications are very comprehensive but on your first visit may appear daunting. Where do you start? And what skills do you need? Hopefully in this chapter and the last you will have realized that this software is certainly not intimidating and can be the perfect companion to your other photographic kit. In fact, you should consider image manipulation applications as just another photographic accessory. You don't need to use it for every shot, but when you do need to it's great to know you've got it.

13

printing your images

In this chapter you will learn:

- how to print your photographs
- how to change the size and resolution for best results
- about different kinds of printers and paper
- about the alternatives to printing yourself

When computers began to dominate corporate office environments in the 1990s, technology pundits promoted the 'paperless office'. They described an imminent business world where everything would be done on screen and the use of paper consigned to history. What happened? Paper use increased fourfold. The technology made it easier to produce documents and reports and people still preferred the hard copy.

It's much the same with digital photography. Digital technology means that we can store pictures on computers, CD, or on the Internet, or send them by email and so on. However, most people prefer photographs printed on paper. Perhaps that's not surprising: prints are easy to share, can be framed and carried around in a wallet. So, even if you print just a small proportion of the photos you shoot that can account for a large number of prints. And, with the huge growth of digital cameras, that means serious numbers of prints are produced every year.

The great thing about digital photography is that you can use your home printer to produce stunning photographs – no need to make trips to your local photo store. Let's begin by taking a closer look at computer printers.

Inkjet printers

Without going too deeply into the technology (for which most of us can remain blissfully ignorant) it's worth spending a moment describing how an inkjet printer – the type that just about all of us will have at home – works. Though there are slight variations between the models produced by different manufacturers, the basic principle is that a print head sweeps back and forth over the printing paper and as it does so very fine drops of ink are drawn through (using heat or electric methods) and fired on to the paper. Clearly, the smaller the amount of ink that can be delivered, the finer the resolution that can be produced.

The inks themselves have complex formulations to ensure that when the ink hits the paper it produces an even spot of colour. Some printer and ink combinations require special paper formulations to get the best results (often paper produced by the same manufacturer) while others are more tolerant of generic papers that are more widely available and, on the whole, cheaper. You will, however, need to specify the type of paper you are printing on when setting your computer to print images. The characteristics of, say, high gloss printing paper and matte paper are different and they need a different amount and method of ink delivery.

Inkjet printer: One like this Epson model can produce prints up to A3 size.

Inkjet printers are also available in different sizes and with the capability of printing on different sized papers. If we ignore those inkjets that are the preserve of the professional printing bureaux (and are capable of printing to widths of a metre or more), the largest home printers typically handle paper sizes slightly larger than A3 size and commonly described as A3+. This enables neat printing of borderless A3 prints, twice the size of A4 prints. Large printers like this do, of course, accept smaller papers – you won't want to print an A3 copy of every image from your camera!

Most of us will have A4 inkjets. These are great all-round printers that spend most of their time on daily household duties – printing letters, school homework and the like – but can be pressed into photographic service when required.

Note that not all A4 inkjet printers are capable of photographic quality printing. Some models – particularly at the lower end of the market – are really designed for general printing duties and don't excel at photo printing.

Though there are some smaller inkjet printers – designed to print to smaller sizes of photo paper – most people tend to use an A4 printer with smaller paper sizes – or will print two or more prints to a single A4 sheet for best economy.

Printing papers

Shooting digital photographs is cheap. Apart from the costs of recharging batteries the cost per shot is minimal. However, you may be surprised when you look at the costs of printing papers and printing inks. The combined cost per sheet doesn't seem to offer a commensurate saving.

Given that both the papers and the inks feature complex formulations that's probably less surprising, but you can still get good value for money by equipping yourself with a range of papers for different applications. Here's a typical selection of photo papers:

- **Photo quality inkjet:** conventional weight paper with a coated surface. Ideal for proof prints but not sufficiently resilient or sharp for long-lived prints.

- **Photo paper:** heavier coated paper for everyday and good quality prints.

- **Glossy paper:** heavier grade glossy paper. Equivalent to cheap conventional glossy printing paper. Surface is glossy but due to the thickness of the paper, is not highly glossy. Good for album prints and usually keenly priced.

- **Premium glossy paper:** much heavier, thicker paper with an even surface and a very high gloss finish. More expensive and suitable for high quality prints. Capable of delivering the sharpest prints. For those that remember, this is probably the closest you'll get to the renowned and exceptionally fine Cibachrome/Ilfochrome glossy paper.

- **Premium lustre/pearlized:** a similar weight and thickness to premium glossy paper but with a silky pearlized surface. Not capable of such a critically sharp print as glossy, but the surface is excellent for use in those situations when reflections could be a problem with glossier paper.

- **Premium semigloss:** similar to lustre paper but with a less glossy surface.

- **Premium matte:** a matte finish heavyweight paper.

- **Archival:** a range of papers (with gloss, pearl or matte surfaces) designed for particular longevity. When used with the matched inks (which may only work with specific printer models or printer ranges) prints made on this paper are exceptionally durable and suitable for long-lived archival uses.

Which is best? It's horses for courses. The premium grades will undoubtedly provide the best results – but at a cost.

Printing papers: there is a wide range of finishes, sizes and weights available from all the big manufacturers. Here are some of Fujifilm's selection.

Standard glossy paper is probably the best compromise: a good finish and a keen price. Unless you've a discerning photographer friend, few will be able to detect the difference.

Beyond these standard printing papers come the more specialized papers and surfaces. For example acetate sheets used for display light boxes and overhead projectors (that tend to have been superseded by video projectors these days) and thermal transfer sheets – for printing onto fabric and T-shirts.

Alternatives to inkjet printers

Though inkjet printers dominate the printer market, they don't have it entirely to themselves. Dedicated photo printers are available that use dye sublimation technology to produce photographic prints indistinguishable from conventional chemically produced ones.

Dye sublimation printers

Dye sublimation printers (or dye-subs for short) use special ribbons that have the inks (or, more correctly, dyes) contained within them. The dyes get released from the ribbon by passing it across a heated print head, with the heat varying according to the depth of colour required. The dye is transferred, one colour at a time, to the paper and an image is built up.

These printers offer very high quality resilient prints but the per-print cost is higher than that of an inkjet.

Colour lasers

Increasingly affordable, colour lasers are now superseding inkjet printers in many homes. They print quickly and a full toner cartridge is enough for a great many copies.

Dye sublimation printer: for fast, simple photo printing, dye sublimation printers are hard to beat.

Unfortunately, when used for photographic applications, the prints they produce are rarely satisfactory, especially when compared with prints from a good inkjet printer. However, for printing proof quality prints – where you may want to check the composition and 'look' of the picture – or for printing large numbers of thumbnail prints for your records they do provide an economic alternative to the inkjet.

Preparing photographs for printing

Not so long ago, when digital photography was a less mature technology, discussions on printing photographs from a computer involved a lot on resolutions and printer settings. Now that digital photography is in the mainstream,

printing processes are much simpler. In fact you'll usually find that your image manipulation software will take care of most of these for you.

Printer driver: the printer driver lets you set your printing requirements.

When you select Print from your image editor's menu, a subsidiary piece of software, the printer driver, will open. This is where you can configure your printer prior to printing. Here you can set:

• The size of the photo you want to produce (there's a shortcut that lets you scale the photograph to fit the paper set in the printer).

• The size of the paper you want to print to.

• The type of paper.

You may have some additional options, depending on your printing needs. The preview window shows any modifications you may have made.

About printing resolutions

Possibly the most confusing part of printing for the newcomer is resolution. We talked earlier about the resolution of cameras (or, specifically, camera sensors). Printers will be capable of printing to a certain resolution, normally expressed in dots per inch. Good photographic printers may offer resolutions of nearly 3000 dots per inch. So does this mean we need to create images with a corresponding resolution? No. The optimum resolution for a photograph is around 300 dots per inch. Anything more than this is beyond the resolution of the printing papers.

So, when you prepare to print, base your image sizes on 300 dots per inch. Though not strictly accurate you can equate this to pixels per inch. If you want to produce a 10 × 8 inch print it will need to be 3000 × 2400 pixels in size (that's around 7.2 megapixels) to achieve optimum quality. In practice, if you use the printer driver to scale your image to fit the media, you will find that a larger image (in megapixel terms) is reduced in size slightly. A smaller image (say 5 megapixels) will be increased in size (to a lower resolution) probably without noticeable degradation.

If you don't want to get embroiled in resolution calculations, don't. Use the scaling features of the driver and print a test photo. If it looks good that's great. If the image looks soft because you have over-enlarged it, then print to a smaller size.

Print packages

Often we concentrate on printing a single print, taking advantage of the whole of the printing paper. But there will be times that you will want to print smaller prints. Then you can take advantage of print packages. These let you print two, four or more prints per page. Better still you can even produce multiple sized prints on a single page. These are ideal when you want to produce a large print, couple of small ones and some wallet-sized copies on a single sheet, minimizing waste.

Print packages: rather like those photo sets you get from schools, packages provide sets of similar or different sized photos on a single paper sheet.

Some printer drivers will also allow you to do what might be described as the opposite of this: produce a very large print from several smaller sheets of paper. Your printer will print, say, four or nine sheets of paper that you can then join together to make a larger one. It's not as aesthetically pleasing as a single large print, but with careful mounting or framing, the results can look good.

Colour and contrast

When you first print photos, that you've previously only viewed on a computer screen, you can be disappointed. Paper is less able to reproduce the range of brightness possible on a computer screen. Prints look duller than on screen. If this is significant, you need to adjust the image before printing. Reducing the contrast slightly (using the Brightness/Contrast control) can sometimes help.

Photo store printing

Inkjet printers offer great quality and – the key benefit for most – immediacy. You can shoot photos in the morning and produce an album's worth of prints in the afternoon. But this is not the only way to get prints from your images. You can also do them via your local photo store or, taking advantage of your computer's connectivity, via online stores.

Copy your best images to a CD and you can walk them to your favourite photo store and ask them to print the images. Photos stores score when you have a large number of images to print or when you want something that your inkjet would not be capable of – large prints, for example. Printing all your holiday photos on an inkjet can be a bit of a chore yet a photo store could produce them in less time than it takes to go shopping in the neighbouring stores. Prices will be competitive too.

Large format printer: a photo store is a good place to go if you want those really large prints – specialized printers such as this are rarely found at home.

Online photo stores let you upload your images to the store's server and then order prints. Often you can save your images on the server so that if you want prints at a later date you can order them.

Better still, some online stores will let you give friends and family access to your online photo collection so that they can order prints directly. This is an excellent way of sharing photos of family events, for example. Instead of emailing selected images to distant relatives overseas you can give them sight of all the images and let them choose the size and quantity for themselves.

196

printing your images 13

Photo by member Donna Wood | Donna & Ricks wedding - photo by Ann Tovey | June 2007 *[submit photo]*

	New	Hot new product	Summer Sale!
• Photo gifts & cards			4p Summer prints NEW
• Services & prices			3 for 2 PhotoBooks
• Offers & news			Wedding gift packs
• Quality Advice			Buy a collage print
• Public Albums	**New bespoke framing.** Order professionally mounted & framed prints online with our new service.	**Introducing new MyCards!** Create personalised contact cards for all occasions. See our introductory offer & order yours today!	Sign up today and get **30 prints free**
• Pro Galleries			
• Ten reasons to join			

Prints online: online photo stores such as PhotoBox let you produce a wide range of print sizes, quantities and put your best photos onto greetings cards, calendars and even mugs!

The downside of consigning your printing to a third party is that you have less control over the results. If you printed your own photos and found that some were below par you can could take remedial action to improve the original, prior to reprinting. Though a photo store will print your manipulated images, you'll have to be more forgiving of the results.

Summary

Nothing beats a great photograph printed to high quality. They will form a centrepiece when framed or become part of a memory-laden album. Printing is fun and undoubtedly very satisfying. Do remember that whether produced at home or in a photo store your prints are valuable. Okay, so if you damage one you can go back to the original digital file and produce a new copy. But it does pay to look after your photos. Consider:

• Where you display your images. Keep them away from direct sunlight or areas of high humidity and damp (such as kitchens and bathrooms).

• How you file them: for best longevity, avoid photo albums that use plastic overlays for the pages – these can react with the photos. Go for traditional paged albums.

• Anti-UV frames: if you are going to frame your prints avoid economy frames and go for anti-UV coated glass. Fading will be reduced and your photos will look good for longer.

Cautionary notes aside, your photos are there to enjoy. Enjoy them!

14 new life for old photos

In this chapter you will learn:

- how to get existing images into your computer
- how to make old photos better
- about repairing damaged photos
- how to get digital copies of your old photographs without using a computer

Your adventures in digital imaging are giving you the chance to shoot more images than ever before. Better still, you are now able to make good images even better. The trouble is, many people who come to digital photography tend to have large collections of photographs they may have taken – or acquired – over the years. It's just so simple and so much fun to shoot digitally that your conventional photographs, slides and albums tend to get relegated to a cupboard, the apocryphal shoebox under the bed, or worse. Many old family archives are destined to be stored in garages and lofts – neither of which provide ideal conditions for the longevity of the photos and images.

This is something of a shame because the older the photographs the more precious the images and the memories they trigger. Wouldn't it be great if we could incorporate our old photographs in our digital archive? Maybe even improve some of those old photos to make them look better than they have ever done before?

You probably wouldn't be surprised to hear that we can now easily do both. In this chapter we'll take a look at the way in which you can produce digital versions of old photographs and then examine how you can use your image manipulation skills to improve these images.

Digitizing old photographs

To add old photographs to our archive we need to produce a digital version in a process called digitizing. When we talk about converting a photograph to a digital form it's important to realize that what is actually meant is to produce a digital copy – the original remains untouched. This is particularly significant if you are planning to digitize important or historically significant images. Whether they are your own or have been borrowed, you can be assured that these originals will not be damaged in any way.

So, how can you produce a digital version of an original? That depends on what the original is. Let's look first at photographs. These are likely to be the more numerous, particularly when, as time goes on, the original negatives from which they were produced tend to get mislaid.

Digitizing photos and flat artwork

Along with photographs we can also consider any flat artwork. For example we might have some press clippings, postcards or even some watercolour paintings that we want to produce digital copies of.

Our tool for this is the flatbed scanner. This device, rather like a photocopier, scans any art placed on its glass panel and, rather than producing a copy, produces a digital file. You can think of it as a specialized digital camera, dedicated to producing accurate digital copies of flat originals.

Flatbed scanners: available in A4 or A3 sizes, the flatbed scanner is ideal if you have a large quantity of prints that you want to digitize.

You don't necessarily need a dedicated flatbed scanner to produce a digital scan. Many of us now own multifunction

devices that combine a printer, copier and scanner in a single unit. The scanner function of these devices is equally adept at producing a digital scan.

Whether you are using one of these or a dedicated scanner, the process is the same. Start the scanning software, set the parameters, scan and, finally, check the result. Some image editing applications let you bypass the scanning software and import a scanned image directly into the application. You can check whether your application supports direct importing of scanned images by looking in the File menu under Import. Look for Import from Scanner (or something similar) or TWAIN driver. This term, less commonly used now, describes the special software used in a scanner. Selecting this will also allow you to import the image.

Remember, some time ago now, we discussed pixel resolution in regard to camera sensors? In particular, how, for better quality images you generally needed higher resolutions and pixel numbers? The same is true when it comes to scanning. We need to scan at a resolution that delivers the best quality digitized images.

When a scanner scans an image you can set the number of points from which it records data – anything from 50 to 4000 points per inch (or dots per inch as it is sometimes called). This measurement of resolution (which has curiously escaped metrication) defines the amount of detail that will be recorded in the digital file. Obviously, the greater the number of points, the larger the resulting digital file.

Unlike digital cameras, however, using the maximum number of dots per inch doesn't necessarily guarantee the best image quality. Once you record the image at a resolution similar to that of the original, no further increase in resolution will provide any better image quality. All you will get is a larger image file. Normally, a setting of 300 dots per inch is sufficient to record good quality originals.

As you scan you can, by activating the appropriate settings in the software, sharpen the images you import by applying a software filter akin to that used in image manipulation applications. My advice would be not to do so. You can always sharpen a digitized image later but if you over sharpen your image as you digitize, it will be impossible to correct subsequently.

Scanning transparent originals

What if you have the original negatives of your photographs or you have a collection of transparencies? Can you use your flatbed scanner to copy these too? That depends. To copy transparent media – such as these – they need to be lit from behind and scanners normally illuminate the media for copying from the front. Some flatbed scanners however,

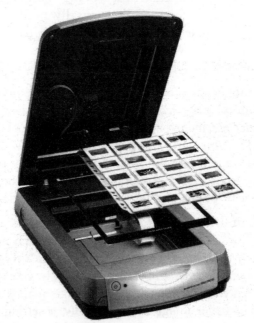

Scanning slides with a flatbed scanner: some allow the scanning of negatives and transparencies.

do feature a secondary light source – mounted in the flap of the scanner – that allows you to scan transparent media in exactly the same way as opaque. Set the scanning software to scan a slide or negative and this secondary light source will take over from the main light. You can work at higher resolutions when scanning originals – up to 4000 dots per inch as both negatives and slides have a higher resolution. The software will even reproduce negatives in true colour – rather than the inverted colours on an orange base.

Using a dedicated film scanner

For those of us with modest collections of negatives or slides, using a flatbed scanner or the scanner feature in a multifunction device is quite sufficient. If you have larger collections then it may not be so efficient or expedient. In this case you could invest in a dedicated film scanner, a scanner that, while acting in the same way as a flatbed, is designed to handle only slides and negatives. These will

Slide scanner: dedicated to scanning slides and negatives, ones such as this Nikon model are ideal for getting the best scans from your collection.

produce quality results enabling you to process a large number of originals in a faster time. The drawback, of course, is that a film scanner is an additional moderately expensive purchase.

Using a camera to copy photos and artwork

Though there are differences in the mechanics, a scanner is notionally just a digital camera. That begs the question: can you use a conventional digital camera to copy photographs? Yes you can. Take a few precautions and you can get some surprisingly good results by photographing your photographs with a digital camera. Those precautions are:

- Mount your camera on a tripod to keep it steady.

- Ensure that your camera is square on to any artwork you are photographing to prevent the risk of distortion.

- Provide even illumination: the originals need to be well lit, and evenly so. An effective way is to position a pair of similar lights one to either side of the original. Position these far enough from the original and the camera to prevent reflections.

- Set the camera to a medium focal length, or longer focal length (as you might for a portrait) to prevent the introduction of lens distortions.

Unless your originals are totally flat you might also want to put a sheet of glass on top to keep them so, and ensure sharp focus across the image.

As good as using a scanner? Not quite. You will get better results by using a scanner optimized for the copying but should you not have access to one, you can get reasonable results using this method.

Problems affecting old images

Sadly, old photographs and images are likely to suffer from one, or more, problems that can degrade the quality. Here are some of the most common:

1 **Physical damage:** The prints or negatives (and we'll use negative here to describe transparencies and slides also) have some physical damage that can be put down to poor handling or storage over the years. Examples might include corners being worn and becoming dog-eared; creases, tears and splits, damage due to drying out (and consequent brittleness).

2 **Fading:** Exposure to sunlight will cause any photographic original, in time, to fade; exposure to very bright or direct sunlight can accelerate this process. The result is faded prints with poor contrast and pale colouration.

Print fading: age, and exposure to light, can fade prints or, as here, reduce the contrast. In all but the most extreme cases you can correct this deficiency later using image manipulation software.

3 **Discolouration**: Even if prints or negatives are stored away from the light they may still be affected. The gases and vapours given out naturally by paints, varnishes and even some cardboard used for storage boxes is of very low concentrations around our homes but can build up in areas where photos are stored sufficiently to cause discolouration of prints. Prints can take on a green or magenta cast and negatives can become more red when printed conventionally.

4 **Water damage**: Moisture is an enemy of your prints and negatives and can cause damage ranging from almost imperceptible water marks through to dissolution of the film emulsion causing it to break up or disappear in sections. The longer photos are stored in such conditions (common in lofts and garages) the worse the ingress and the consequent damage.

5 **Flora and fauna**: The presence of moisture can even cause more insidious damage as it provides the right environment for bugs and mould to grow. Mould can invade prints and negatives. It shows up in the latter as white blemishes when a positive print is produced (conventionally or digitally); some strains will appear as plant like growths across the frames. Bugs, their eggs and their droppings leave corresponding shadows. Obviously, because a negative is enlarged to produce a print, infestation on these is more significant (and obvious) than on an enlarged print.

Using image manipulation software

You should not be surprised at this stage that these problems can be corrected using image manipulation software. It is important to realize that when we talk about correcting problems no software – no matter how good it is – can put back information that has been lost. It merely gives us the

means and the tools to camouflage missing elements. Let's look at how we can correct each of the problem areas we have outlined above.

This is not detailed advice on image repair and rectification. It's designed to help you repair and restore images. As you attend to each problem you should come to appreciate the abilities and the limitations of the tools at your disposal. Though image retouching can require a high level of skill the repairs here are relatively simple and convincing results can be achieved very quickly. With a little practice, you'll achieve even more realistic repairs.

Physical damage

Repairing physical damage is a job for the Clone tool. Where parts of an image are missing – such as on a worn corner, a tear or even a crack – you will need to use the Clone tool to paint over the damaged areas on the digital copy of the image. Normally (and this does depend on exactly what needs to be covered) you would select pixels nearby as the start point for cloning and then brush over the damage. The Clone tool will continue to select pixels as it tracks along a course parallel with that which you are painting. You might be sceptical, but the results will be very convincing. As your cloning skills improve your technique will be sharpened and you'll get even better results.

You'll get the best results if you select a brush for your Clone tool that has soft edges. When you select the Clone tool you'll find that you can select a brush of different diameters and even different shapes. You can also select different levels of softness, from a very hard, sharp edge to a very soft one. The soft edge ensures that any cloned pixels will blend seamlessly with the original image.

Repair job: the original image here was faded, unsharp and suffered some physical damage. Each of these has been attended to using image manipulation software. The result? Possibly better than the original was prior to damage.

Remember that, should you make a mistake, or should the repairs be too obvious, you can remove them by selecting the Edit menu and then Undo (or, depending on your application, the Step Backward menu option).

Fading

Correcting faded prints can be simple: apply one of the auto correct tools, such as Auto Contrast or Auto Levels. Either of these should restore the proper contrast range to your photo. We say 'should' because these automatic corrections do assume that your image has a conventional range of brightness and contrast. If your image does not – perhaps it has large areas of shadow or, conversely, large bright areas, the corrections may not work satisfactorily. In these cases you can adjust the Levels (see Chapter 11) or use the Brightness/Contrast tool to adjust manually.

Correcting fade: the Brightness/Contrast control is ideal for quick fixes to images that are lacking in contrast or a bit dull.

Discolouration

Similarly, discolouration (whether visible in the original image, or introduced when you make corrections for fading) can be corrected using the Auto Colour tool. Also, Auto Levels can sometimes attend to this, and fading, at a stroke. Otherwise, select the Colour Balance control which will let you adjust the different colour levels in the image, for example, reducing the amount of green or increasing the amount of blue. The exact adjustments you need to make will depend upon the colour casts caused by the discolouration.

A useful tip is to identify an area in your image that should be white or a neutral grey and adjust the colour balance to neutralize any cast on these areas.

Water damage, flora and fauna

We can regard these problems together. Rather like physical damage, these produce image-degrading elements that need to be treated by painting over.

Enhancing old images

Sadly, many old images don't have just one of these problems. They are likely to have several. When you come to enhance them you will need to work in a systematic order so that you get the best from the editing and correcting process. Here's the typical sequence of corrections, and the suggested tools for making those corrections:

♦ Adjust the contrast and brightness: Brightness/Contrast, Auto Contrast or Auto Levels.

♦ Correct any colour balance problems: Auto Levels, Color Balance, Variations.

♦ Increase the colour saturation: Hue/Saturation.

♦ Repair damage: Clone/Rubber Stamp.

♦ Sharpen: Unsharp Mask.

Finally you may want to use the Crop tool to trim away any rough edges. This can be more efficient and give a cleaner result than trying to use the Clone tool to fix worn edges.

Once you've made all your corrections, save your image. You can now run off a print – or prints – in the knowledge that should your new print be damaged when on display or being shown off to friends you can return to the original digital file and produce a new copy.

Digitizing old photographs without a computer

If you don't have a computer, or you have a computer but don't have the peripherals (such as a scanner) to make the digitized copies you can still preserve old images for posterity.

Many photolabs will produce digital versions of photographs and put these on to CD for you. Some will also put them on CD in a form that you can enjoy either individually or as a rolling slideshow on TV.

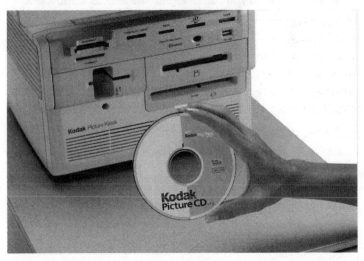

Photos on CD: some kiosks at photostores will put your images – from digital sources as well as negatives and slides – onto CD.

Some labs will also undertake corrections and enhancements to damaged photos – delivering you a pristine copy of an original print or a digital file for you to print yourself.

Summary

Digital photography is not just about shooting great photographs – it's about preserving and enhancing the past too. Most of us have collections of old photographs and digitizing these gives them a new lease of life and prevents the risk of them deteriorating (or deteriorating further).

Unfortunately, due to the high technical quality of many photographs we shoot today, old photographs can look less impressive, so it's useful to know that you can improve on those originals once you have captured them digitally. And if you don't want – or have the means – to attend to this yourself, then you can delegate the task to a photolab.

15 photography without a computer

In this chapter you will learn:

- how to connect your camera and printer without a computer
- how to edit images in your camera
- how to get prints without having a printer
- about drawbacks and limitations and how to overcome them

Many digital photographers spend comparatively little of their time shooting photos and considerably more manipulating and editing the results on a computer. Others would rather spend their creative time out shooting and getting their photographs as near perfect as possible in the camera. If you fall into this latter group this chapter is particularly suitable for you. We've made the presumption that you don't have a computer, or access to one, for image editing but still want to get the best from your digital camera. In some respects you'll be in the same position as the conventional photographer: you'll take the images but rely on someone else – or something else – to produce the images to produce the photographs. Fortunately if you choose not to use a computer you'll find you are not alone and that a whole industry has grown up to serve your needs.

Let's take a look at the options available.

Connecting your camera to a printer

Whereas images are normally downloaded from a camera to a computer and then printed via a printer attached to it, we can cut out that middle stage, connecting a camera directly to a suitable printer. You may be surprised and pleased to know that there are a number of printers that allow this direct connection. Some are ordinary printers, designed to be connected to a computer but which have this additional connectivity; others are stand-alone printers dedicated to printing direct from a camera.

Printers designed for printing digital images often give you the option of connecting the camera directly or using in-built memory card slots to read the images from the card. Either method will provide the same results.

These printers also tend to have on-board LCD monitors that not only display menu options but also give you a preview of the images prior to printing. You can also select

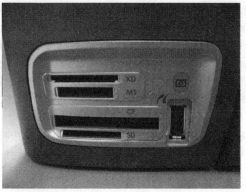

Printer card slots: many printers now feature slots to enable memory cards to be directly slotted in and read.

a thumbnail view that will print out a sheet of small thumbnail images, allowing you to choose which ones to print. You can even take advantage of enhanced features courtesy of the PictBridge standards, of which more in a moment.

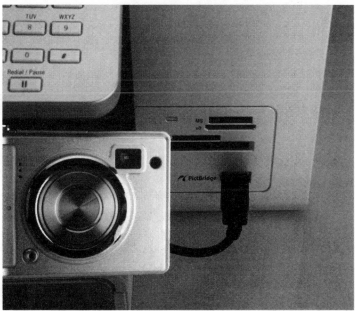

Printer connection: some cameras and printers can be directly connected to print stored images.

Depending again on the printer, you will also be able to apply corrections to your images akin to those that users of digital image manipulation software will be familiar with. Adjustments include brightness, colour (increasing or reducing the saturation) contrast and sharpness. Arguably, making the corrections immediately prior to printing in this way is quicker than doing so on a computer although, of course, any corrections that you apply will not be saved to your image file.

PictBridge

If you go shopping for a printer – or a camera for that matter – you might see compatibility with the PictBridge standard mentioned somewhere in the specifications.

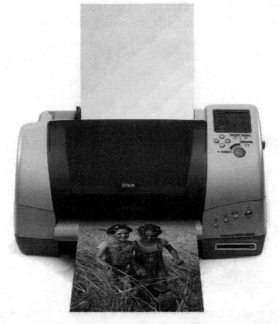

Inkjet printer: a printer such as this is equally at home connected to a computer, connected to a camera or printing directly from a memory card. Accepting paper up to the width of A4, it can also print panoramic images.

PictBridge is a technology standard that allows printing on a conventional printer direct from a digital camera or memory card. The camera and printer don't even have to be of the same brand. Link compatible printers and cameras and you have access (via the LCD panel on the printer or camera) to a host of special features. You can choose the print size, number of copies of each print and even crop your images to improve the composition.

If you are fortunate enough to have more than one digital camera and they are all PictBridge compatible then you can use the same printer for them all. (It's worth noting that some camera phones and digital video cameras are also PictBridge compatible.)

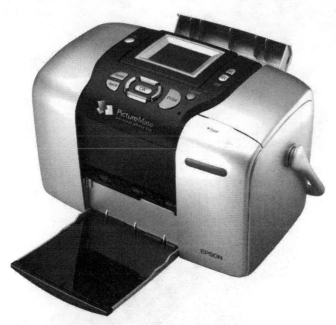

Dedicated photo printers: photo printers can deliver photorealistic prints in just a couple of minutes direct from your camera.

Wireless connections

Whether you use PictBridge or the conventional features, when you link your printer and camera that link is normally a physical one, typically via a USB cable. There is an alternative offered by some cameras and printers, and that is to communicate wirelessly, using Bluetooth or wifi. It should be emphasized that not all printers and cameras offer this form of connection – it's actually more common, in the camera world among camera phones. If you are fortunate enough to have the right hardware then you can

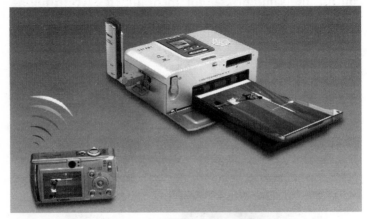

Wireless printers: look, no wires! This Canon camera and matched printer connect wirelessly.

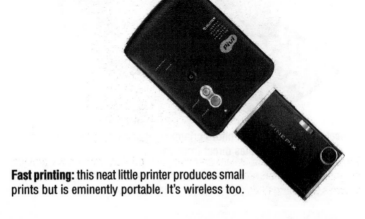

Fast printing: this neat little printer produces small prints but is eminently portable. It's wireless too.

do away with the cables completely and print directly from your camera. In practice there are no significant advantages in communicating via Bluetooth, but there's no doubt it's convenient not to have to communicate via a cable.

Dockable cameras

Some manufacturers produce printers that allow you to dock a specific camera directly into them. The combined unit becomes an enhanced printer: you use the camera to control the printing and the LCD monitor serves to walk you through the printing process. Docks recharge the camera batteries too, but the downside is that these devices tend to produce only modest-sized prints – to a standard size of 6 × 4 inches, for example.

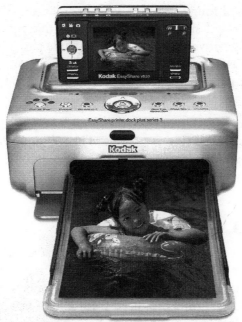

Dockable printers: convenient and compact, printers with docks provide integration of camera and printer features and ensure that your camera batteries are charged as you print your best shots.

Editing images in your camera

Because there is the fair presumption that the majority of users of digital cameras will be connecting to a computer at some point, the features offered in-camera for editing are limited. They may amount to little more than the ability to vary the sharpness of an image or the colour balance.

Some editing features can be configured prior to shooting too. On the whole these tend to be of the special effects variety. You can, for example, specify that your image is shot in black and white, given a sepia tone or a special effect applied. I rarely, if ever, find a use for these, as they all tend to degrade the image. You too will probably want to get the best possible from your photography and shoot the best possible images in the first place.

A useful tool found in some digital cameras is a stitching feature. This is designed to stitch together (that is, seamlessly blend) consecutive shots to produce a wide panoramic one. Combine this with a printer capable of printing on panoramic paper or a paper roll and you can produce some very long and very impressive panoramic shots.

Rarely, if ever, will you have the opportunity to crop your images in camera prior to printing. The solution? Print your images larger than you need and trim them to size – simple but effective.

Printing without a printer

If you don't have a printer then you can have your images printed at a photo store, just as you would from conventional film. You can take your memory card to the store and have prints produced from all the image files or you can select specific images to have printed.

As well as a drop-in service, many photo stores offer a kiosk service where you can choose which images to print and

how they are to be printed. These self-service kiosks are simple to use and can deliver prints (normally up to A4 size) in just a couple of minutes. Some kiosks will also offer limited editing facilities. You'll be able to crop images, remove red-eye on flash shots and flip horizontally and vertically. More dubious facilities are also offered in some kiosks, such as text printing, speech bubbles and distortion effects.

Printing at a kiosk: kiosks are simply computers dedicated to printing. Memory card slots are ranged across the front and, when a card is inserted the images contained on it are shown as thumbnails on the screen. Choose which you want to print, along with the size and that's it.

Photo stores also offer a wide range of additional services that will also appeal to those that do have a computer: have your images printed onto mugs, T-shirts and other media, ideal for giving as presents to family members.

The drawbacks of photography without a computer

There are two key drawbacks to digital photography without a computer. First, you are limited to the amount of post-shooting manipulation you can do. Second, you don't have somewhere to download your image files to release your memory cards for future shooting sessions. Let's look at the ramifications.

Limited manipulation

Use this as a positive attribute. It may be controversial to say so, but there are many photographers (and I would not exclude myself here) who don't always pay full attention to what they are shooting. They will take short cuts or, for the sake of speed, ignore certain elements in the image on the pretext that any shortcomings can be corrected later when using image manipulation software. It's lazy and bad practice. You wouldn't do the same with your conventional camera would you? Having limited manipulation opportunities should make you, if you forgive the pun, more focused on getting great photos in the first place. It's a sobering way to improve your technique!

Coupled with a good quality printer (and it's fair to assume that without a computer your principal way of viewing your best work will be as prints) you will be able to make modest adjustments to your images to overcome any shortcomings due to slightly incorrect exposure or colour balance. That's better than you can expect if you were to take a film to be printed on the high street.

Your image files

This is a more serious issue. Without a computer you will be limited in making backup copies of your digital image files and, without the means of downloading your image files to another medium you'll either need more and more memory cards or have to discard many of your images.

You can, though, have your images transferred to a CD, for example, at your local photostore. CDs are reasonably robust and provide a good way of storing your photo collection. In some photo stores you can even have your pictures put onto CD along with viewing software that will allow you to view your images as a slideshow on a TV as well as on a computer.

There are some accessory devices that offer the ability to burn a CD direct from a memory card or from a set of cards. It depends on whether you want to invest in additional hardware (and make disks relatively cheaply) or pay a little more per disk to have it produced for you.

Summary

Often digital photography is considered synonymous with computers. Part of that association comes from the early days of digital photography when most photographers still took conventional images with a film camera and only manipulated the digital files from those images.

Now the tables have turned. Far more people own digital cameras than own (or might choose to use) computers. As a result a huge industry – bigger than that of conventional photography – has arisen to meet the demand of all these photographers. If you don't want to edit or store your images on a computer then you don't need to feel too disadvantaged. True you won't be able to exploit all that digital photography has to offer, nor will you have the ability to waste hour after hour creating imagery that is wild or wacky. But it will still be fun!

16 fun projects

In this chapter you will learn:

- how to create a professional photo album from your digital images
- how to put a collection of photos onto CD or DVD
- how to create slideshows
- how to share your photos in emails and across the Internet
- how to make movies with your digital camera

You've mastered your camera, image manipulation software no longer holds any fears for you and you can print away to your heart's content. Soon, if not already, you'll be itching to see where else your digital photography skills can take you. In this chapter we'll look at some of the fun activities that, armed with your new-found skills, you can join in.

Creating a professional photo album

Photo prints are still very popular and, if sales of photo paper and processing services are anything to go by, more popular than ever. What becomes of those images when they are printed? Some large ones make it into frames to be shown off around the home. Others get kept in files and folders. Some, usually the best selection, end up being stuck into albums – just as we have done with photographs for a century or more.

Albums are due for an update, and today you can create dynamic, professional-looking albums from your photo collections. Better still, rather than printing out and pasting photos into an album, once you've designed your album, it, complete with photos, captions and even accompanying stories can be printed directly into a hardbound book. Many online photo labs offer this service including PhotoBox. Here is how to use their service.

1 Select your images

It's a good idea to start by sorting out the photos you want to include in your photobook. Take a good look at each and weed out any that are blurred or a bit below par. They will look worse when printed and can let down the whole album. A modest selection of great shots is better than a larger collection with some mediocre images.

2 Add additional material

When you create your photobook you may want to include

Image selection: select only your best images. Discard anything that's not first rate – they will let down the whole album.

material other than photos. For example, children's drawings; a wedding invitation; even clippings from a newspaper. You can scan these just as if they were old photos or use your digital camera to photograph them, close up.

3 Fine-tune your images

For your album to look its best you'll want all your photos to look their best. Use your favourite image editing application to tidy them up. Some may need a little sharpening. Others may need the colour boosting a little (nothing like increasing the colour saturation a touch on holiday snaps to make them more impressive – and make friends really envious!).

4 Upload images

If you are using a service like PhotoBox, you can use selected

images already stored in your account. Some applications like iPhoto work in a slightly different way and allow you to create an album offline, only uploading once you've completed your project. If you are uploading images for the first time do make sure they are large enough (that is, have sufficient resolution) for the size of album pages you'll be using.

5 Choose a style

Most photobook applications will let you choose from a wide range of album types and styles. You can have a softback or hardback album, classically styled or contemporary. You can even select art book styles for those really impressive portfolios. Choose a style that is most appropriate to your subject.

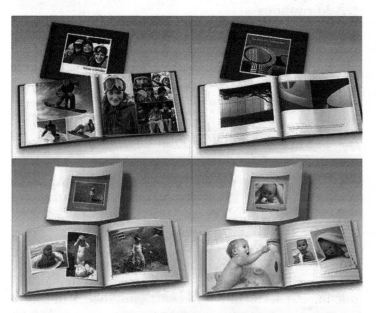

Photobooks: you can create photobooks – the modern equivalent of the photo album – in any one of a variety of styles and with quite different layouts.

6 Design your pages

In some photobook applications the pages can be automatically filled with your images. However, for best results it's better to design and fill the pages yourself – that way you can be sure you have the layout that best suits your images. You can drag and drop the different page templates (from the selection along the bottom of the screen) into any chosen order.

7 Drag and drop images onto the pages

Time to put your album together. Drag and drop images onto the pages. You can rotate images, crop or resize them to fit the templates. You can even change the book style or modify the templates if you feel it will improve the layout.

8 Add captions

Most photo albums don't need much in the way of captions but it's always a good idea to include a few words. You can use the captioning facility to add some memorable comments or some location details. It's surprising how easy it is to forget details even after a relatively short time!

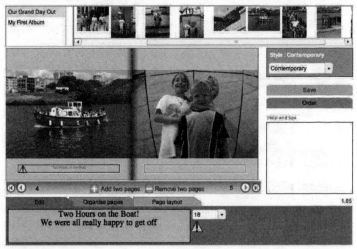

Compiling a photobook: you can use the software tools provided for the photo-book to customize your album pages.

9 Order your book!

Once you're happy you can order your book. You can save your photobook too – ideal if you want to order more copies in the future. A saved book can also be modified later should you want to add to it. Next time you could even choose an entirely different style or format.

Putting your photos on CD and DVD

Putting your photo collection on a CD, or a DVD, is not in itself a fun activity – it should be a routine part of your photographic life. You can copy your images to a disk to provide a backup just in case, as we mentioned earlier, something catastrophic were to happen to your computer.

Making extra copies of your backup disk is an efficient way of sharing photos – you can send a disk of images to friends and family and let them print their own copies.

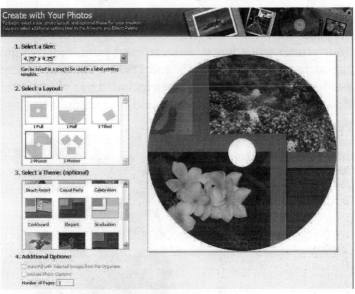

Creating a label: creating a label for your finished CD or DVD is simple with applications such as this (Photoshop Elements).

However, as well as copying the relevant files over as a mere backup – worthy though that is – you can also create slideshows of your images that will play like a commercial DVD when used with a conventional DVD player.

The software to do this is actually contained within some image-editing applications but if the application you are using doesn't have the feature, separate applications are widely available. Windows users might like to try something like Easy CD Creator; Macintosh users can try Toast, or even the free application included on your computer iDVD.

When you create a slideshow you can either go for the rather prosaic parade of individual images or something more dynamic. You can configure the software so that you can zoom in or out on specific images, or scan across them. You can even combine both effects. Used sensibly it makes for a much more powerful slide show and one that will be eminently more watchable.

Once you have created your CD or DVD why not create an insert for your DVD case and a label for your disk? If your printer will allow it, you can even print directly onto the surface of printable CDs and DVDs. The software to produce labels and inserts is often included free with printer driver software or else can be found on the Internet.

Personalized DVDs: once you've copied your images to disk, whether as a simple slide show or something more compelling, you can create case inserts and even print a label for the disk itself.

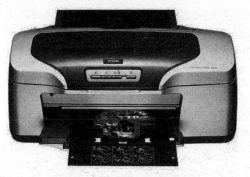

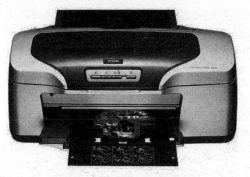

Windows XP can also reduce file sizes for emailing. Select the image(s) you wish to send, and pick Email this file from the File and Folder Tasks list. A dialogue box will then invite you to Make all my pictures smaller. Select this and click OK, and Windows will put the image(s) into an email ready for you to add text before sending. This can be a very useful tool for people who don't want to manipulate their photos or to be encumbered by additional photo applications.

Creating a photo-based website

Sharing photos by email is a good way of passing on photos conveniently and quickly but it has one drawback: when you send an email it goes to a single recipient or perhaps a handful of people.

If you have photos that you are happy to share, why not make them more widely available? Creating a website photo gallery means that anyone who goes to the website address can see your images. The easiest – though for some the least satisfactory – method is to sign up with a photo-sharing website. These let you upload images and share them with others. A variation on this is the service offered by some online photo stores. These places have a commercial interest in having you store your images with them – they hope that you'll turn to their photofinishing services for printing. But the photo sharing is free and simple.

If you want to go the whole hog and create your own web gallery you'll need to put in a little – and it is just a little – more work.

You'll begin by using some web gallery software to create your gallery and associated web pages. You don't need to know anything about HTML – the language used to create web pages – or the technicalities, because the software will create it all for you. Some applications, including Photoshop and Photoshop Elements, include all the relevant software.

In minutes you'll have created web pages that you can preview using your computer's web browser.

Now, to publish your web pages on the Internet you'll need to upload them to a website. Your ISP (the company you use to connect to the Internet) may offer website space and the means to upload. There are also networking websites that offer space (often for free) to which you can upload. If none of these appeal, you can buy – for a modest cost – some web space.

When you've uploaded your web pages you'll want to publicize your site. Unfortunately many websites that you get for free – and some that you pay for – have tortuous and utterly unmemorable web addresses (which people need to type into their web browser to find the page). You'll be more successful in getting people to visit your site – and publicizing it – if it has an easier and more memorable name.

Give it a simple name – such as your own name followed by (say) .com or .net – and you'll get many more visitors. To do this you'll need to:

1 Find out if the name is available (and hasn't already been purchased by someone else).

 You can find out if it is available by visiting a company that registers website names (called domains). There you'll find a 'check domain' feature. Type in a name and it'll tell you if the domain is available to buy. If it isn't it may advise you of alternatives.

2 Purchase the name.

 If the name, or a suitable alternative, is available you can buy it. It will cost only a few pounds a year, and you normally take out a two-year subscription.

3 Redirect visitors who type in your new name to the main website where the photos are stored.

 Once your payment has been accepted and a couple of days have passed (to allow for processing) you can direct

traffic from this new site to the existing website. What this means is that anyone who now types www.yourname.com into their web browser will be directed onto that complex and forgettable web address.

Once you have created your website you can then modify and add to it. The secret of a successful web photo gallery is having good images and continually adding to or 'refreshing' the content. A small selection of powerful images will make the site more compelling than a large collection of so-so photos. Adding new photos regularly makes sure that people, impressed by your first offering, will come back for more.

Note that some camera manufacturers also have photo gallery websites – as do Apple for their .mac subscribers. The latter allows you to use the iWeb application to create and publish web galleries in minutes.

iWeb: applications such as iWeb make the creation and publishing of websites easy – and that includes photo galleries.

Movie-making with a digital camera

The movie mode offered by many still digital cameras is a surprisingly useful feature but one that is rarely used to the full. Okay, a camera with movie mode will never replace nor be as good as a dedicated digital video camera but you'll be surprised by the quality you can achieve.

You'll find most digital cameras will offer two resolutions for video. The higher of these may be described as VGA or 640 × 480. Think of this being good – rather than excellent quality – and on a par with VHS video. The other quality QVGA is one quarter of that, 320 × 240. This is much lower quality but produces smaller files suitable for sending as email attachments.

The ultimate quality of the video depends not only on the resolution but the number of frames – individual images – recorded per second. Conventional TV offers 50 frames. While many still cameras offer this too, some offer only 15 or even 10. The lower the frame rate the less smooth the video.

Sound quality is also variable. A few cameras offer very good quality stereo sound but, as a rule, you'll get mono.

Unlike digital video cameras that can record an hour's high quality video on a tape (or a disk, or hard disk, depending on model), with a still camera you will be limited to the capacity of the memory card. Some cameras also set a limit to the length of an individual clip.

When you've shot your video clips, what can you do with them? You can view each of them individually. They can be downloaded to your computer just like, and along with, the still images on your memory card, then viewed simply by clicking on them. This is fine, but if you've shot a lot of clips of the same event wouldn't it be great if you could link them all together as a movie?

You can. You can use software included with your computer (such as Windows Movie Maker or Apple's iMovie) to edit and combine clips. You can even add music, titles, captions and special effects. Did you expect, when you took your first tentative steps with your digital camera that you'd be in a position to create a mini movie blockbuster?

Enjoying your movies: once you've create a movie you can save it on your computer or even produce a copy to show off on your iPod!

Practice

Have a go now at:

◆ Creating a slide show on DVD.

◆ Putting together a photo book – and getting it produced.

◆ Creating a website. That's a little tougher than the other activities but once you've created one and launched it on the Web you can refine, hone and modify it to your heart's content. The more you play, the better you'll get – and the better your website will be!

Summary

Your digital camera, you'll have realized long before now, is not a mere replacement for an equivalently specified film camera. It's a gateway – a gateway to a great range of activities and opportunities just a few of which have been outlined in this chapter. Better still, the more you explore these opportunities the more you'll discover is possible. Have a go at some of those that we've discussed in this chapter. Like digital photography itself, these extended activities often cost very little yet the enjoyment you – and others – will get, exceeds any costs.

17

bitten by
the bug

In this chapter you will learn:

- some ideas for more fun with your camera
- where to find out more about digital photography and image manipulation

By now you'll be conscious – and hopefully at least a little excited – about the opportunities that digital photography offers: everything that conventional photography can do and a lot more besides. However, one thing it does not offer is the hassle – no need to wait to see the results of your photography or have to visit photo stores to deposit your film.

In the last chapter we explored some of the unique opportunities of digital photography; now let's take a brief look at some more. These will both exploit the skills you've gained so far, push your limits and set you on a path to shoot some really impressive photos. Later on, we'll take a look at some websites that can provide additional resources – and additional ideas – to take your digital photography even further.

Shooting photos

We've commented several times through this book that digital photography gives you terrific scope for shooting photos. Because you can see the results straightaway and you have no significant costs, you can afford to experiment and, in doing so, learn. In the days of conventional film photography, that learning process was much longer and more drawn out as photographers waited hours or days to see their results, before moving on to refine their technique. Now we can do that in seconds. Here are some specific skills that you can perfect in (almost) no time at all.

Shutter speeds and long exposure

If your camera has the option for varying the shutter speed and aperture, it's worth getting to know what these changes can do. And the best way to do this is to shoot scenes at different shutter speeds. Here are some ideas.

Water: find a river or waterfall and shoot a scene at different shutter speeds: 1/250 second, 1/2 second and 2 seconds (more if your camera will allow). You'll get three different and quite distinct results. The brief exposure will freeze drops of water in motion giving you – literally – a snapshot of the scene. During the long exposure the water will have moved significantly and delivered a shot where the water has become misty and dreamlike. Totally unlike the brief exposure, no individual droplets will be visible. The 1/2 second exposure will give a rather mediocre shot: utterly representative, but not showing the river to the best.

Movement: Set a longish shutter speed (say half a second) and shoot moving subjects. Move the camera to follow the subjects. Now set a faster shutter speed (1/250 second or faster) and do the same again. You'll see that the long exposure will have enhanced the feeling of motion. By following the subject that subject will be relatively sharp yet the background will be blurred, proportional to the motion. The short exposure would have been brief enough to freeze both the subject and background, so it would be difficult for anyone viewing the image to get a handle on the amount of motion or the speed of the subject.

Shoot photos for online auction sites

If you are a keen eBay user you'll know that good product shots sell well. Most people who shoot photos for their online auction sales, sadly, pay scant regard to the quality of their photographs. Poor quality, out-of-focus shots don't show your sale items to best effect and can also be wasteful of your time. If your potential buyers can't see objects clearly, or can't see specific details, they are likely to ask you endless questions. Worse still, they may be put off, fearing that the objects are not as good as described, thereby losing potential bidders. So how do you make sure you pre-empt all those questions? Here are a few tips:

- Always use a support when shooting if the light is low, or you're getting in close. That support doesn't have to be a tripod. Propping your camera against some books or bracing against a wall can be equally effective.

- If your camera lets you set a high ISO speed you can set this to get good shots in low light too. Photos for web use need to be good but, as you're not going to display them at ultra-high resolution (as you might when printing), high ISO speeds are fine.

- Learn to use your macro setting. Your camera works really well close up to objects, so find out how close you can get and practise with some trial shots.

- Use a plain background when shooting. You'll show your sale items to best effect if there's no distraction from flowery wallpaper or a marble worktop!

- Shoot the real sale item. That sounds an obvious remark, but avoid using a library or promo shot of your sale item, as the avid collector will notice straightaway. The detailing of your actual item is crucial.

- Shoot lots. If you've a valuable item, don't penny pinch by just including a general shot. Avoid endless questioning from your buyers by including shots from all angles, any wear and tear on the base (if relevant) as well as any damage.

- Show details. Have you ever wondered why some copies of books – not necessarily first editions – command far higher prices than others? It all comes down, essentially, to rarity. Collectors are often willing to pay a particular premium for a copy or version that is, in some way, special. If you have something like this for sale it's crucial that you include photographic evidence. That evidence might be the page of the book where the edition information is printed, a special mark on a coin or notable colouration on, say, a stamp or poster.

• Avoid reflections. This is the most common cause of angst amongst buyers. An otherwise great shot is spoilt by a 'hot spot' reflection due to the flash from your camera reflecting from the glossy surface of your books or annuals rendering it impossible to accurately gauge the quality. Instead, switch your camera's flash off and rely on daylight. If it's not feasible to shoot outdoors and you have to resort to shooting near a window, make sure your camera is well supported.

Avoiding reflections: it's important to show your subjects at their best – so reflections are unacceptable. Use your new-found photo skills to avoid them.

• Show damage. With books, magazines and paper-based objects damage is inevitable and increases with age. That damage could be physical – bending and creasing of pages, spine damage to books or pen and pencil marks – or chemical, discolouring through age. Damage is undoubtedly the most contentious area when selling: what we, as sellers may consider mild damage or describe as 'good for age' might be regarded as something much less acceptable by a discerning buyer. Avoid any possible dispute later by including photos of any damage.

Record the change in lighting during the day ... and through the year

We talked earlier about how light changes through the day and that your camera can either hide or enhance the changes. One way of understanding the changes, and getting a great series of photos too, is to shoot a single scene through a wide range of lighting conditions.

Set your camera up on a tripod and position it in a way that you can repeat at different times. You might want to mark the position of the feet, or frame your photo in some way that is easily repeatable – you won't want to leave your camera alone for the whole day!

Start at first light and record photographs every hour, say. Do this even if you don't think there has been any change in the lighting conditions. Continue through the day until twilight – later if there is any artificial lighting in the scene.

Now take a look at the resulting images – and pick out the best to produce a sequence of, say half a dozen. You'll get an impressive array of images for mounting and a better impression of how light does change through the day.

Don't stick with a single day's shooting. Repeat at different times of the year and in different weather conditions.

A great way to use all the shots you record in this way is to compile them into a time-lapse movie. If you've acquired some video editing software you can string your still images together – displaying each for a second or two. If you don't have any video editing software don't worry – set the images to appear in a slide show but set the interval between slides to just a second.

Exploit the extremes of the day

There's no doubt that most photos are shot in the middle part of the day – from mid morning to late afternoon. That's something of a shame because if you explore the more

extreme parts of the day you'll get some extra special photos. Around dawn and dusk when the glorious colours of sunrise and sunset have either passed or are yet to come, head out with your camera.

At these times you'll get very warm coloured lighting that will enhance your photos – particularly portraits. The angle of the lighting will also be very low, giving lighting effects quite unlike anything you'll get at other times of the day. This makes for some intriguing landscape shots. Light does tend to change very rapidly at this time of day, both in warmth, colour and angle, so stick around and shoot profusely.

If the results initially seem disappointing, this may be because your camera's white balance setting is incorrect. If set to auto it will be doing it's best to neutralize any colour casts; switch instead to the daylight setting to retain the warmth.

Use the macro button

By now you may well have experimented with the macro, the setting that lets you shoot very close up. If not, give it a try. The great thing about macro is that it opens up a whole new range of subjects that, at conventional focal lengths and with conventional photography, can be less than inspiring. So, macro is also an opportunity to shoot subjects close at hand when the weather outside is poor.

Just think about subjects that you could explore and you'll find the list is almost endless. Here are just a few:

- Plants and flowers: get in close to reveal the intricate patterns and details of the stamens.
- Wildlife: if a bee or wasp happens to be feeding off a flower you are shooting it can make for a great wildlife shot but other creatures can also look spectacular – if not a little intimidating, when shot in macro mode.

- Coins and stamps: these become real frame-fillers with macro mode.

- Models and hobbies: scale models can assume life-sized proportions.

- Objets d'art: other objects around the home, from cutlery through jewellery and miniatures and on to household items, become surreal art when shot up close. Change the angle of view to make them look even more unusual.

Macro: you can get in really close with your camera's macro setting and record detail barely visible to the unaided eye.

Set your camera to macro and get the feel for how close you can get. Depth of field – the amount of the image in focus at any one time – is marginal in the macro mode so a tripod (or other form of support) can be essential, but often freehand holding of the camera will let you get close to subjects – such as bugs and insects – in a way that is unlikely to be successful for a tripod-mounted camera.

Getting up close: the macro setting is also ideal for recording details of your favourite objects.

Take your camera underwater

As well as shooting different subjects, you can extend your photography by taking it into different terrains, and one of the most popular is underwater. You'll probably be pointing out that water – especially sea water – and delicate electronics don't mix. However, many digital cameras can be taken underwater thanks to housings supplied by the camera manufacturers.

For those that don't have a custom housing, there are the flexible underwater bags produced by companies such as Aquapac that let you take any camera underwater. All housings are good to at least 10 metres' depth, which is ideal for most applications. Once underwater you can use your camera much as you would on the surface. The automatic exposure system and autofocus will work in exactly the same way. It's a good idea to turn off the flash as the flash firing within the housing could obliterate images – instead, turn up the camera's ISO sensitivity to allow shots without flash.

Aquapac: the Aquapac is a great way to take any camera into the water – or sandy environments and get great photos without any risk of damage.

Underwater systems: for the dedicated, underwater housings such as this from Fujifilm protect both the camera and the flash.

Shoot a theme

Here's a great way of focusing your photographic skills – shoot a theme. That theme could be one based on a colour, an object or even a shape. Seek out all the different types of object corresponding to the theme and shoot them in as many ways as possible. Your aim is to explore whatever subject you've chosen and capture it through some great photos.

As well as getting some fantastic shots, exploring a single subject like this will help you develop a strong eye for good photographic compositions and you'll come to appreciate why some photographs work and why some don't.

Manipulating photos

Image manipulation is a great way to make a picture a little bit special; to improve on an already-good photograph. But we can go further and create artwork from images.

Combine images into a collage

Here's a quick way to put together some images with a common theme – such as those you might have collected in the example we've described above – or perhaps some photos of children and grandchildren.

Rather than the traditional form of collage, the one that involved scissors and glue, the digital version lets you compile your collage onscreen. You begin by creating a new document in your image editing application – just as you would a new document in Word, or perhaps Excel.

Then, open each of the images you want to use in the collage, select the whole image, or part of it, and paste it into your new image document. Step by step you can build up your collage. If some of the images are the wrong scale, or the wrong size, use the Transform command to adjust.

Collages are a good way to produce intriguing composite images.

Once you're done, save the image. Remember that you've been working with copies, not the original images themselves, which remain untouched.

Try some montaging

Take collage a step further and you can enter the fascinating world of montaging. This involves cutting out selected parts of one image and placing it in another, with the aim of creating a new whole. It's basically what we described earlier when we looked at the Clone and selection tools. In this process you use the relevant selection tools (based on the colour or shape of the subject, for example). Then use the Copy command to copy the selection and the Paste command to paste it into a different image.

This is the technique you would use if you want to assemble a group portrait, for example, from people in different original photographs. Unlike collage where it is obvious that the different elements are different photographs, the aim in montage is to make the result look totally seamless: as if, in our example of a portrait, all the characters had been together in the first place.

It's not easy to create convincing montages but, start with something not too ambitious, and the skills quickly develop. Problems to watch out for include:

* The wrong colour: different photographs may have been shot under different lighting conditions so when combined the differences will be more obvious. You can counter this by using the Colour Balance control. Some photo editing applications make the job easier by using auto fix controls to adjust and match the colour balance.

* Rough edges: when you make a selection, even with a steady hand, there's a risk that you'll not cut out the subject properly. You can make this less obvious by using a small feather amount (just one or two pixels) so the boundary of your selection is not hard. When pasted into your new image, the soft edges will help the selection blend better.

* The wrong light: even if the contributing original images look well matched you could get some visual gaffs if the

lighting is not right. Imagine you're compiling the group picture. All the subjects were shot with the light illuminating them coming from the right except for one, where the light was coming from the left. When you combine the images into one you'll get an obvious and absurd lighting effect where shadows contradict each other. There's no real way around this – you'll just have to choose an alternative image.

Shoot a panorama

For those extra wide views nothing beats a panorama. To shoot one, don't set your camera to wide angle – the resulting image will feature a band of interest across the centre and too much foreground and sky that are basically a waste of space. Enlarge the panorama itself and you'll quickly run out of pixel resolution.

Instead, select a telephoto setting on the lens and just shoot the central band of the scene, moving the camera sideways between shots – making sure that consecutive shots overlap by around 30%. Now use the panoramic tool in your photo

Photomerge is a simple way to assemble photos of adjacent parts of a landscape into a full panorama.

editor (in Photoshop and Photoshop Elements it's called Photomerge). This will automatically assemble all your images into a single wide shot.

Photomerge: the finished panorama.

The good thing about a tool such as Photomerge is that it can accommodate an image as wide as you want to make it – 360 degrees if you wish. You can also create vertical panoramas: a combination of shots taken by raising the camera each time – to accommodate a tall building or landmark for example.

You may find some of the shots don't blend seamlessly throughout and this might require you to use your newly found skills with the Clone/Rubber Stamp tool to tidy up.

Turn your photos into artworks

Here's something we touched on earlier. You can apply a filter to your image and turn it instantly into an artwork, making it appear to have been painted or drawn. It doesn't work with all subjects so you'll have to experiment to ensure that you get an effect that enhances rather than detracts from your original image. Here's a shortlist of effects to try:

• Solarize: inverts and increases the saturation of parts of the image. Good for action shots and adding drama.

• Posterize: reduces your image to a preset number of colour tones: turns photos into bold graphics.

- Crosshatch: suggests a painting created using dry brush strokes criss-crossing the image.

- Palette Knife: an oil painting effect that does give a slight impressionistic look.

- Rough Pastels: makes a photo look as though it was drawn in rough pastels. Use bold or pale colours for different effects.

Create greetings cards and calendars

Unless you've resorted to a pro-grade photo editor such as Photoshop, your software will include a set of projects that you can use. Rather like the photo books we discussed earlier you can use these to create photo-based products including greetings cards and calendars.

You could create any of these – and more – freehand but why bother? The templates contain all the elements you need and will step you through the process of creating the layouts, adding the images and even adding additional text. All you need do then is print out the results.

Enjoying your photography

Digital photography is not just about creating images to print or turn into artworks. There are far more ways to enjoy it. Here are just a few.

Share photos on your iPod or PSP

As well as keeping your photos on your computer or posting them on a website, it's now feasible to carry them everywhere with you on your iPod. Great for showing to friends and family (you can connect the iPod to a TV if squinting at the small screen proves problematic) and also a great way of keeping an extra backup of the images. The software provided with the iPod makes it simple (and largely

automatic) to transfer images to it and, once on, you can view them individually or as a slideshow.

You can do much the same with a Playstation Portable – or almost any other portable media device, although the amount of material you can keep with you will be determined by the amount of onboard memory. You'll need to follow the instructions with your device with regard to loading images.

Slideshow: your iPod or even a PSP can be an ideal way to show and share your digital photo albums.

Stage an exhibition

Why not? Exhibitions are not just for the professionals. If you've shot something worth sharing then why not do it. Shots of local historical scenes, curios or a powerful theme can be of wider interest in the community. Good places to consider for exhibitions are village halls, community centres and libraries, or you could contact your local photographic society.

I hope, as you've made your way through this book, that digital photography, rather than being anything to fear, is simple and empowering. It provides a way for you to keep accurate records of events in your life that will lead to stronger, fonder memories. There are many things that make digital photography so compelling. For some it's the ease of use. Back in the days of early photography George Eastman, the founder of Kodak, launched the Box Brownie camera with the slogan 'You press the button, we do the rest'. The implication was how simple photography – at the time – had become. Now, a century later, and with a different technology, we have come to realize how simple photography has become. And now there's no need to divest any part of the process to a third party.

That brings us, rather neatly, to another reason why digital photography has become so popular. It allows even the novice to create great photographs. Photographic skills can be gleaned more quickly and prints delivered swiftly. And we no longer need restrict ourselves to conventional media. Our images can be shared in so many ways, bringing photos and images into every aspect of our everyday lives.

Yes, digital photography is simple but it's also part of what the popular press has dubbed the digital revolution, a revolution that has seen almost every aspect of our lives – from television through phone technology, radio and

communications – enter the digital domain. That means digital photography can be your entry into a much bigger world just ripe to explore. This is where your adventure really begins!

Resources

Digital photography has become so popular that the Web is awash with sites dedicated to helping, informing and developing your photo skills. Below is a selection that you might find useful. Please bear in mind that websites do occasionally disappear, and sometimes the names change but the information below was correct at the time of going to press. Check via your favourite search engine for the latest information and for additional resources.

Independent camera information

Ephotozine: www.ephotozine.com

Digicam Review: www.digicamreview.com

Digital Photography Review (DP Review):
www.dpreview.com

Steve's Digicams: www.steves-digicams.com

Main camera manufacturers

Canon: www.canon.com

Fujifilm: www.fujifilm.com

Kodak: www.kodak.com

Leica: www.leica.com

Minolta: www.konicaminolta.com

Nikon: www.nikon.com

Olympus: www.olympus-global.com

Panasonic: www.panasonic.com

Pentax: www.pentax.com

Sony: www.sony.com

Software companies

Adobe: www.adobe.com
Arcsoft: www.arcsoft.com
Apple: www.apple.com
Corel: www.corel.com
Extensis: www.extensis.com
Ulead: www.ulead.com

glossary

We've tried to avoid jargon wherever possible through this book but digital photography sits astride the worlds of photography and digital technology and so has garnered its fair share. Listed below are the key terms and jargon you're likely to encounter on your digital adventures – along with a plain English definition.

Accessory shoe: standardized mounting found on top of many cameras for the attachment (principally) of external flashguns and other accessories.

AE: *see* Automatic exposure.

Analogue: method of recording signals in a continuously varying way, rather than in numerical form as in digital recording. Conventional film photography can be described as analogue.

Angle of view: the angle of a scene that a specific lens covers, measured across the diagonal of the frame.

Aperture: the opening in a lens that allows light though. This is controlled by an iris diaphragm under manual or camera control and is varied along with the shutter speed to achieve correct exposure.

Aperture priority mode: an exposure mode where the photographer selects the aperture and the camera will set a corresponding shutter speed.

ASA: American Standards Association; used in photographic context to measure the sensitivity of film. Superseded by ISO which uses a similar sensitivity scale, and a scale that is also applied to image sensors.

Aspect ratio: the ratio of the width of an image frame (or sensor) to its height. Can also be applied to television screens and film.

Automatic exposure: a camera setting (used in digital and film cameras) where the camera assesses and sets the aperture and shutter speed.

Automatic flash: electronic flash that is activated automatically when light levels fall. Normally this can be overridden to prevent the flash operating when not required.

Backlighting: sometimes called contre-jour; subject lit by a strong light source from behind. This will result in underexposure of the subject, or silhouetting unless fill-in flash is used, or exposure compensation applied.

Bridge camera: *see* Hybrid camera.

Burst mode: in a digital camera, the ability to shoot a number of images in close succession.

Camera phone: mobile phone with integral digital camera.

Card reader: device allowing memory cards to be read by a computer. Most memory card readers will accept more than one format of card. It saves having to connect a camera directly to the computer.

Centre-weighted metering: metering system that biases the metering towards the centre part of the frame on the basis that this is where the subject is likely to be placed. The default setting of many cameras' metering systems.

Charge-coupled device (CCD): the imaging sensor used in the majority of digital cameras.

CMOS image sensor (CMOS): an alternative image sensor to the CCD using different technology and favoured for its lower power consumption.

Colour balance: *see* White balance.

CompactFlash: memory card format popular because of the ability to write to and from fast and high capacity.

Compression: a way of storing an image file more compactly to allow more image files to be stored on a memory card and to speed up the transfer of the files over the Internet.

Compression, lossless: a file compression regime that compresses a file without losing any of the original data or compromising image quality.

Compression, lossy: a file compression regime that compresses a file (often to a much greater degree than with lossless compression) by discarding some of the data. When the image is reconstituted there is a drop in quality proportional to the amount of compression.

Contre-jour: *see* Backlighting.

Depth of field: the distance between the nearest and farthest points that are in acceptably sharp focus in a photograph. Depth of field varies with lens aperture, focal length, and camera-to-subject distance.

Digital: in our context, representing media (which may be an image, video or audio track) as a numeric code which can be interpreted by a computer.

Digital video: any video format or system that records video information digitally. Formats such as DV and HDV are digital formats, VHS and Video 8 are analogue formats.

Docking station: a unit normally connected to a computer into which a digital camera (still or video) can be docked to download images or video and charge the on-board batteries.

Downloading: the process of transferring images (and any other data) from a camera to a computer.

Dye sublimation printer: a computer printer that uses heat to transfer dyes to a receiving sheet of paper. Capable of high quality printing, suitable for photographs but more costly than alternatives.

DSLR: Digital SLR – *see* SLR.

Electronic viewfinder: a viewfinder used in hybrid digital cameras (and many digital video cameras) that uses a small LCD panel behind a conventional viewfinder eyepiece. Provides a medium resolution image that is not prone to the effects of bright lighting (which normally affects LCD monitors on the back panel of a camera).

Exposure: the amount of light falling on the image sensor of a camera when taking a photograph. Varied by adjusting the aperture and the time the shutter is open.

Exposure compensation: the adjustment of a metered exposure to allow more or less light through to the sensor in order to compensate for (usually) the brightness or reflectivity of the subject. You might reduce the exposure to expose dark subjects properly, if they would be over-exposed with automatic exposure.

Exposure/focus lock: a feature found on some top compacts and SLRs that allows the exposure settings or the focus to be locked either by partially pressing the shutter release, or depressing a separate button.

Finepix: the name for digital cameras produced by Fujifilm.

FireWire: a fast data transfer system used for digital images and (especially) digital video. This is the colloquial name for IEEE 1394, popularized by Apple Computer, the first company to widely adopt the system. It is also called i.Link on Sony equipment.

Flash, fill in: a burst of electronic flash used in bright lighting conditions to prevent dark shadows. Needs to be accurately balanced with the ambient lighting for best effect.

Flash memory: a memory chip that can store data and not lose it when power is switched off. Used for digital camera memory chips.

Flash, ring: a special unit that attaches to a camera lens for shadowless macro flash photography.

Flash, slave: a separate flashgun that will trigger when it senses a flash from a gun directly under the control of the camera. Used where it is impractical to connect the flash unit directly.

Focal length: the distance from the centre of the outermost lens element of a camera lens to the imaging sensor, when the camera is focused at infinity. Normally expressed in millimetres, the focal length also determines the angle of view of the lens and the amount of a scene that can be included in one shot.

Focus: the point where the light rays from a subject are brought together to form an image.

Focus lock: *see* Exposure/focus lock.

Frame rate: mainly used in digital video, the number of image frames that can be recorded per second.

f-stop: a geometric scale that indicates the size of the opening of a lens aperture. Each subsequent f-stop (when numerically increasing) represents an aperture one half of the previous (e.g. f2, f2.8, f4, f5.6). Sometimes contracted to simply 'stops'.

GIF: Graphics Interchange Format: a common graphics format used on the Internet and in web pages.

Grey scale: a scale of 256 discrete tones in digital imaging that represents black as 0 and white as 255. Also used to denote a monochrome (black, white and grey) image.

Guide number: a relative rating of an electronic flash's power when carrying out manual calculations of exposure.

Hot shoe: *see* Accessory shoe.

Hybrid camera: an informal name for cameras that are ostensibly compact designs but have some features and specifications found on SLR cameras.

IEEE 1394: *see* FireWire.

i.Link: *see* FireWire.

Image buffer: an area of memory in a digital camera that can store images awaiting downloading to the memory card: used when shooting a number of images in quick succession, at a faster rate than can normally be downloaded to the memory card.

Image manipulation application: software designed to edit and manipulate digital images. Photoshop is the best known of these.

Image sensor: an electronic device that is used to convert an image into an electrical signal. Comprises an array of pixels each comprising a light sensitive area called a photosite.

Inkjet printer: computer printer that uses a technique where minute quantities of ink are 'sprayed' onto paper. Most inkjet printers are capable, with the appropriate papers, of producing photo quality prints.

Interpolation: a process used by some cheaper digital cameras to produce images with a high number of pixels from a sensor with a lesser number. Intermediate pixel values are calculated from those on either side. Interpolated images don't offer any more detail or resolution than that of the source image sensor.

Inverse square law: in photography, an interpretation of the law of physics in which the intensity of light decreases

by the square of the distance, so that for example, if you double the distance, intensity will fall by a factor of four.

iPhoto: photo downloading, cataloguing, storage and editing application found on all Macintosh computers.

iPod: media player and storage system from Apple capable of storing digital images and video, as well as music.

ISO: International Standards Organization – in photography these initials denote the sensitivity of film and the equivalent sensitivity of an image sensor. Higher numbers indicate higher sensitivity.

Ixus: name of many digital cameras produced by Canon.

JPEG: Joint Photographic Experts Group – gives its name to a file format used to store images on memory cards and computers, popular because it allows files to be heavily compressed though at the expense of absolute quality (lossy compression).

Landscape mode: an image recorded in horizontal format (compare with portrait format).

LCD monitor: the screen at the back of digital cameras used to preview images and review photos recorded by the camera.

Lithium ion: rechargeable battery commonly used in digital cameras.

Lossless: *see* Compression, lossless.

Lossy: *see* Compression, lossy.

Macro: strictly used to describe reproduction where the image size is the same, or larger, than the original object. Tends to be more loosely used in digital photography for extreme close-ups.

Macro mode: a switchable lens mode designed to allow photography of small objects at a large scale (*see* Macro).

Matrix metering: a camera metering system that evaluates the exposure at a large number of points across the scene before evaluating an overall exposure.

Megapixel: one million pixels: used to describe image sensors (5 megapixels = 5 million pixels).

Memory stick: a memory card system developed by Sony and used in many different devices from cameras through to TVs and computers.

MPEG: Motion Pictures Expert Group – the initials are used as the name for a series of video file formats (common formats are MPEG 1, MPEG 2 and MPEG 4).

Multiple exposure: a single image comprising two or more image exposures that are superimposed in-camera. Similar effects can be produced digitally using computer-based image manipulation software.

NiCad, NiCd: nickel cadmium battery – once popular, now largely superseded by the more effective NiMH and Lithium ion types.

NiMH: nickel metal hydride battery. Efficient and long-lived rechargeable battery type used in digital cameras (and elsewhere).

Noise: in digital photography, interference produced by random fluctuations in an electronic circuit. Most obvious in digital images recorded using high ISO settings.

Optical viewfinder: camera viewfinder that relays an actual image (rather than an electronic one) to the eyepiece.

Orientation sensor: a sensor found in some cameras that determines the orientation of the camera when shooting and which then encodes this information on the image so it is automatically displayed in the right format.

Overexposure: allowing too much light to reach a sensor, compared with the assessed exposure. May be done accidentally, or intentionally for creative purposes.

Panorama: a photograph that has an aspect ratio wider than that of a conventional image sensor and a particularly wide (up to 360 degrees) angle of view.

Panoramic mode: a digital camera mode that allows multiple shots to be conjoined to produce a wide (or a tall) panoramic shot. The same effect can be produced from individual shots using image manipulation software.

Photosite: the small central area of a pixel on an image sensor that records the brightness and colour information. Some (such as the Fujifilm SuperCCD) use two photosites for each pixel to record better brightness information.

Photoshop: image manipulation application produced by Adobe, the leading application used by virtually all professionals and enthusiasts and priced accordingly. A trimmed version, Photoshop Elements, provides much the same functionality at a lower price.

Pixelation: the results of enlarging a digital image, or part of a digital image too much so that individual pixels become visible.

Pixels: contraction of picture elements – the individual elements that comprise an image sensor and, consequently, a digital image.

Portrait mode: a photograph (not necessarily a portrait) shot with the longest dimension upright (compare with Landscape mode).

Preview screen: alternative name for LCD monitor panel.

Programme/program exposure: an automatic exposure system where aperture and shutter speed are set according to a program optimized for the majority of shooting situations.

Rangefinder: a camera device that uses a triangulation system to determine subject distance and hence good focus. Very rarely used with digital cameras.

RAW format: an image format produced by digital cameras that does not impose any compression or post processing, allowing the photographer to extract the maximum quality and information.

Recycle time: the time between shooting a digital image and the camera being ready to shoot another; image buffers can reduce the effective recycling time.

Red-eye, red-eye reduction mode: a flash mode that fires single or multiple preflashes to induce closing the iris of subject's eyes prior to the main flash. Sometimes useful in preventing the retinal reflections that appear as bright red.

Resolution: the amount of detail that can be resolved in a digital image (though it applies to all imagery), based on the number of pixels that comprise it. Higher resolution images contain more detail and can be enlarged further when printing without the pixel nature becoming visible.

Scanner: a device that can be used to input photographs and other artwork into a computer. Special backlit scanners can also input negatives and slides. There are also slide scanners designed specifically for this purpose.

Shutter: the mechanical device in the camera that opens to allow light from the scene through to the imaging sensor and effect the exposure.

Shutter priority mode: an exposure mode where the photographer selects the shutter speed and the camera sets the aperture automatically. This mode tends to be used for action photography and fast moving subjects.

Shutter speed: the length of time the shutter is kept open to allow an image to be formed on the image sensor.

Single lens reflex: camera in which the same lens is used for producing images and feeding the viewfinder. Most – but not all – SLR cameras also feature interchangeable lenses.

SLR: *see* Single lens reflex.

SmartMedia: a once popular form of flash memory card that is now less common due to limitations in capacity.

Spot metering: metering mode where an exposure reading is made from a small discrete area of the scene (normally indicated by a circle at the centre of the viewfinder).

Stop: *see* f-stop.

Stop down: to decrease the lens aperture (that is increase numerically the f-stop).

Super wide angle lens: *see* Wide angle lens.

Tagged Image File Format: an image file format popular in digital cameras that, unlike JPEG, is lossless. A TIFF imaged does, however, require more storage space.

Telephoto lens: a lens with a long focal length that has a narrower angle of view than a standard lens or human eye.

Through-the-lens: a metering system that measures exposure through the lens used to take photographs (rather than using an external sensor that measures ambient lighting conditions). Also used to describe the viewing system in SLR cameras where the viewfinder displays the scene through the prime lens.

TIFF: *see* Tagged Image File Format.

TTL: *see* Through-the-lens.

Two thirds: a standardized sensor format that uses a 2:3 aspect ratio and used in cameras from Olympus and Kodak.

Ultra wide angle lens: *see* Wide angle lens.

Underexposure: intentional or accidental reduction in exposure resulting in less light arriving at the sensor than an accurate exposure assessment would suggest.

USB: a communications system between a computer and peripherals (including cameras) for the transfer of data. USB2 is a faster version of the original USB.

Viewfinder: a device for seeing what will be recorded on your photos.

White balance: a camera control that can be set to automatic or manual, and ensures that the colours in a scene are accurately reproduced no matter what the lighting conditions. Can be disabled if a photographer wants to introduce deliberate colour casts.

Wide angle lens: a lens with an angle of view wider than a standard lens. Those with a wider angle of view are sometimes called super wide, and those wider still, ultra wide.

xD Card: a memory card format introduced by Olympus and Fuji (and others) designed to be very compact and allow large capacities.

Zoom lens: a lens that lets you change focal lengths on the fly.

index